NEW ENGLAND

Portrait of a Place

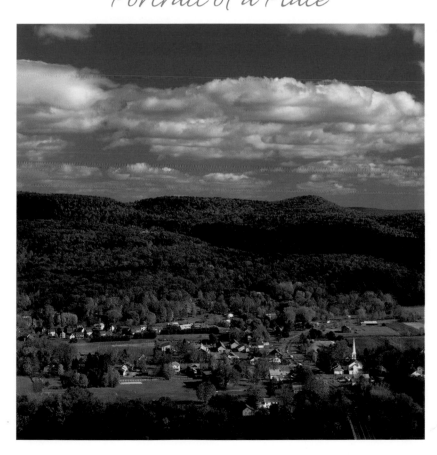

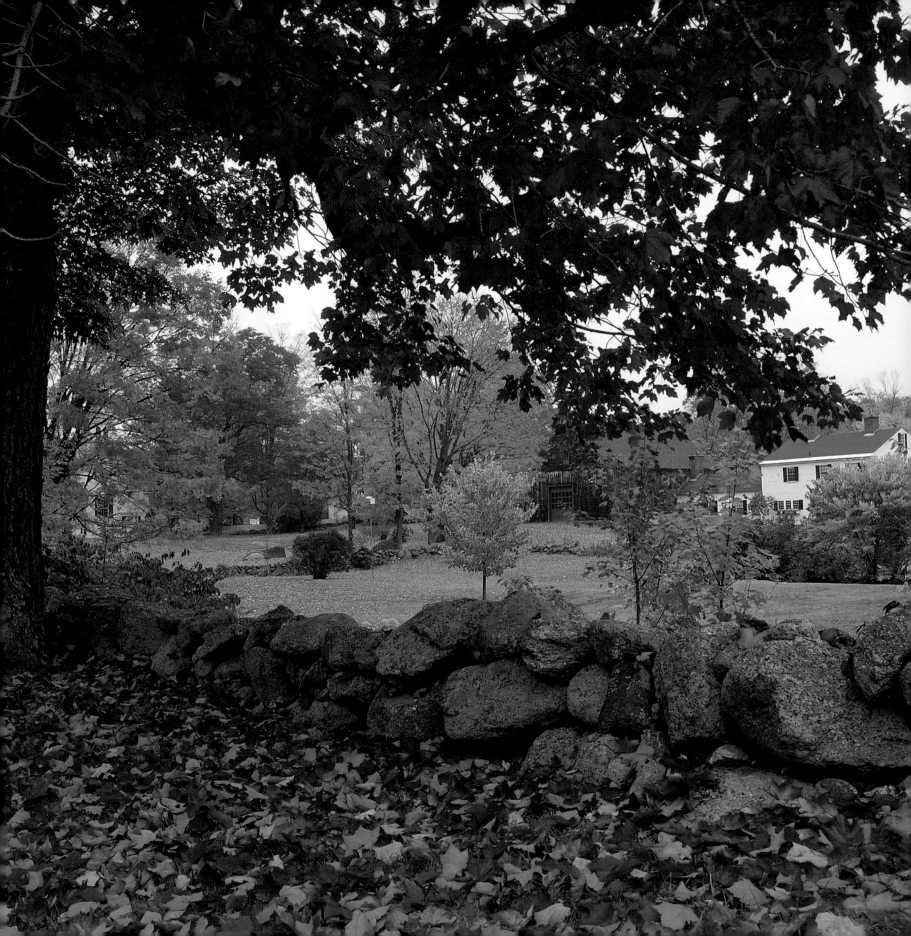

NEW ENGLAND

Portrait of a Place

WILLIAM H. JOHNSON

GRAPHIC ARTS™ BOOKS

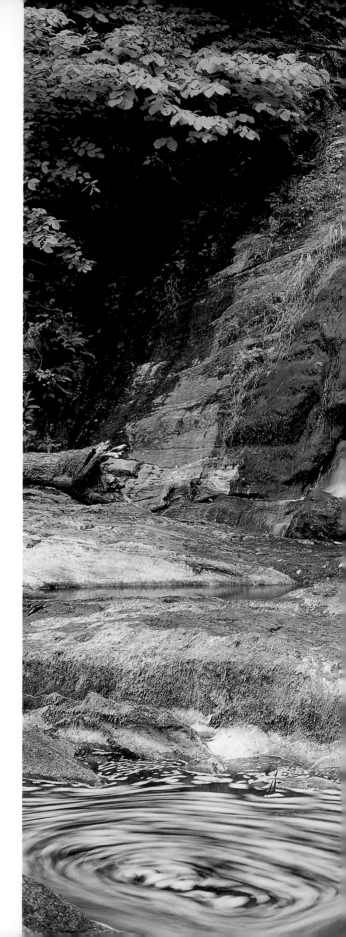

Library of Congress Control Number: 2005936451
International Standard Book Number: 978-1-55868-950-3

Captions and book compilation © MMVI by
Graphic Arts™ Books
An imprint of Graphic Arts Books
P.O. Box 56118
Portland, OR 97238-6118
(503) 254-5591

Dust jacket Design: Vicki Knapton
Interior Design: Jean Andrews

Printed in China
Third Printing

◄◄ Sunderland, Massachusetts, incorporated in 1718, was named for Charles Spencer,
the third Earl of Sunderland (c. 1674–1722). The town's earlier name was Swampland.
◄ Hillsboro Center, New Hampshire, the birthplace of President Franklin Pierce (in
office from 1853 to 1857), was incorporated as the town of Hillsborough in 1772.
► One of Connecticut's most visited waterfalls, Kent Falls, in Kent Falls
State Park, cascades some 250 feet on its way to the Housatonic River.

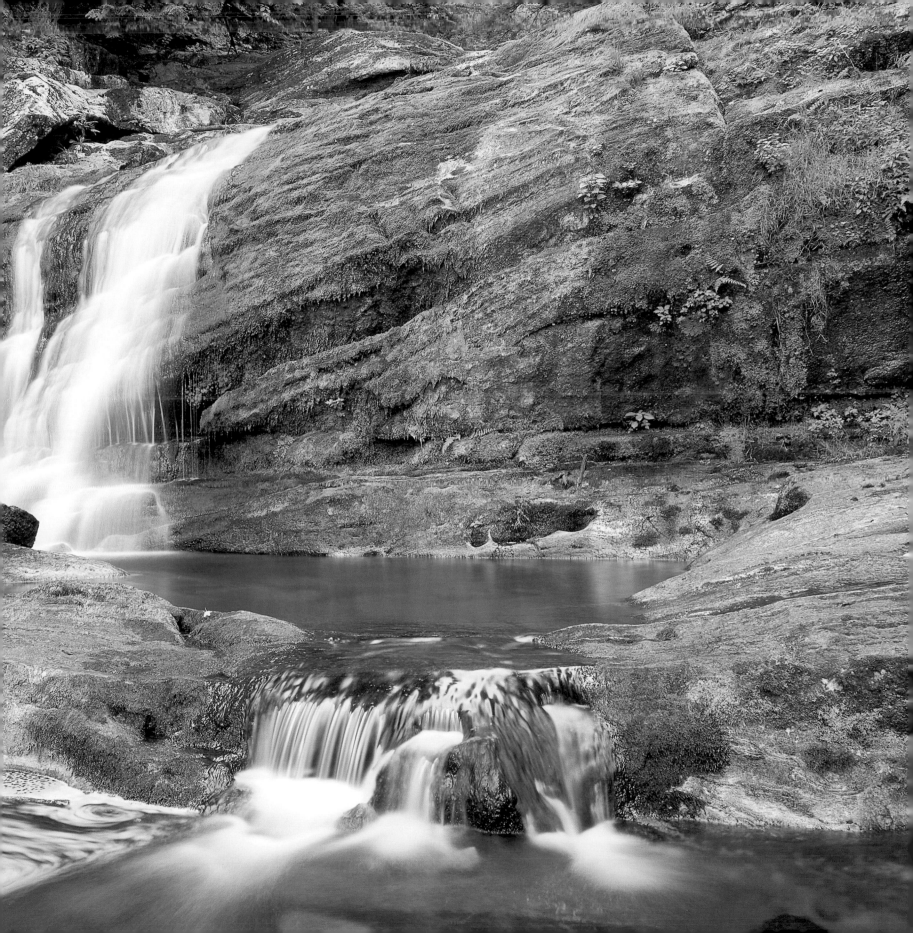

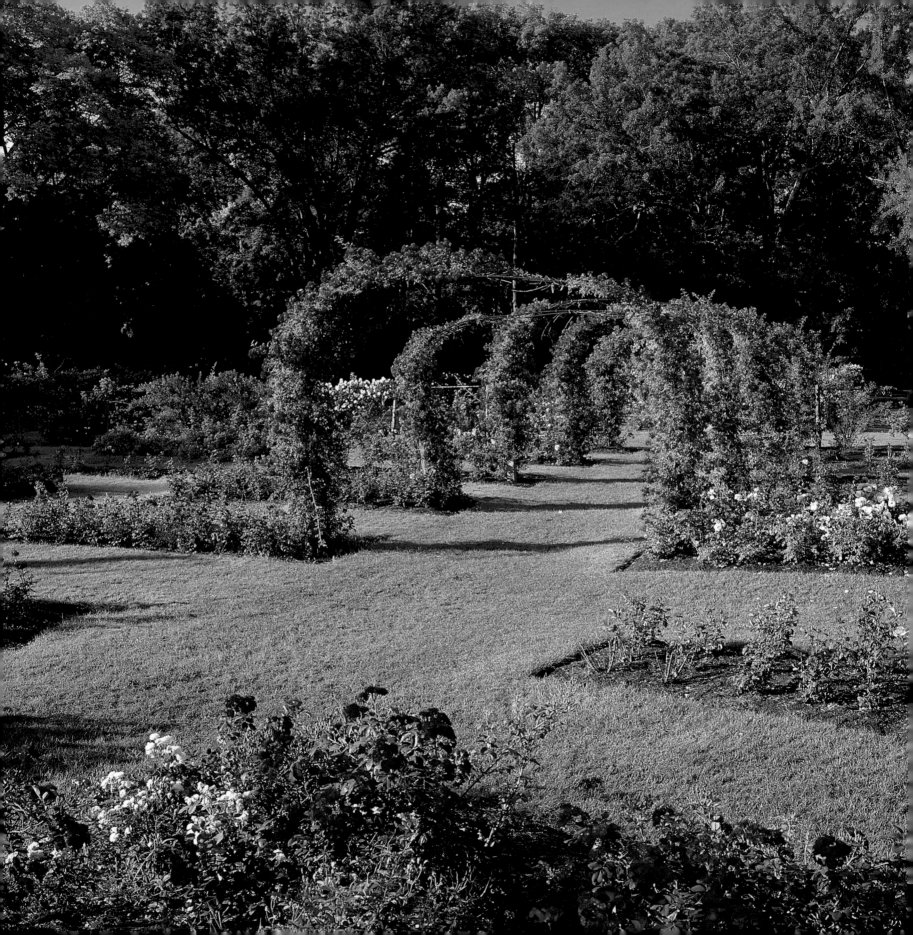

◄ Embracing some 15,000 bushes and
covering two and one-half acres, the Rose Gardens are
the centerpiece of Elizabeth Park of Hartford, Connecticut.
▲ Gravel pathways guarded by boxwood hedges, some of them
original, mark the grounds of the historic Bowen
House, in Woodstock, Connecticut.

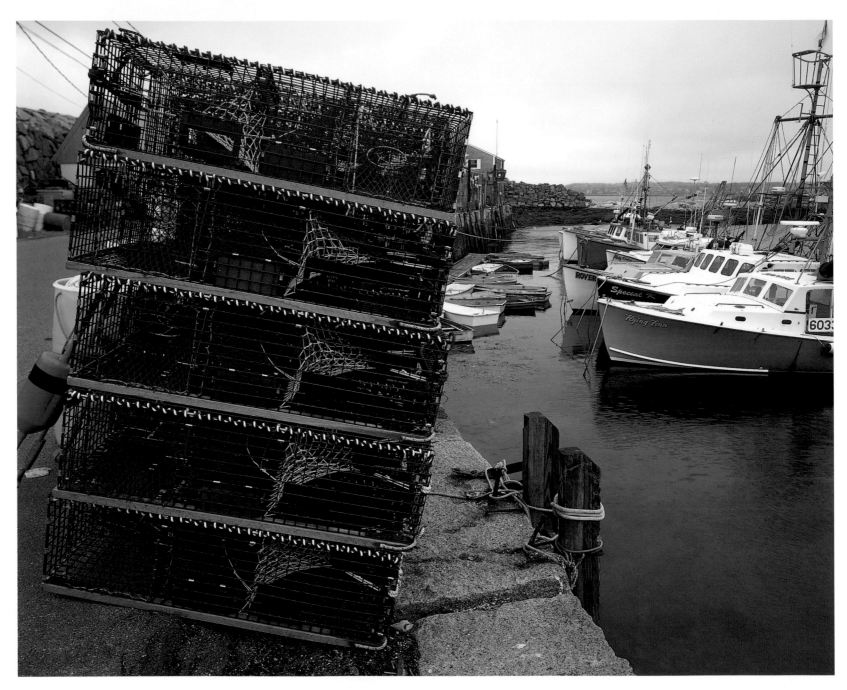

▲ Lobster pots wait on the dock at Rockport's
Pigeon Cove on Cape Ann, just an hour north of Boston.
Steeped in rich seafaring and art history, Rockport boasts miles
of lovely beaches, boulder-strewn paths through woods and
glades, and an enchanting evening light that has inspired
painters since Winslow Homer (1836–1910).

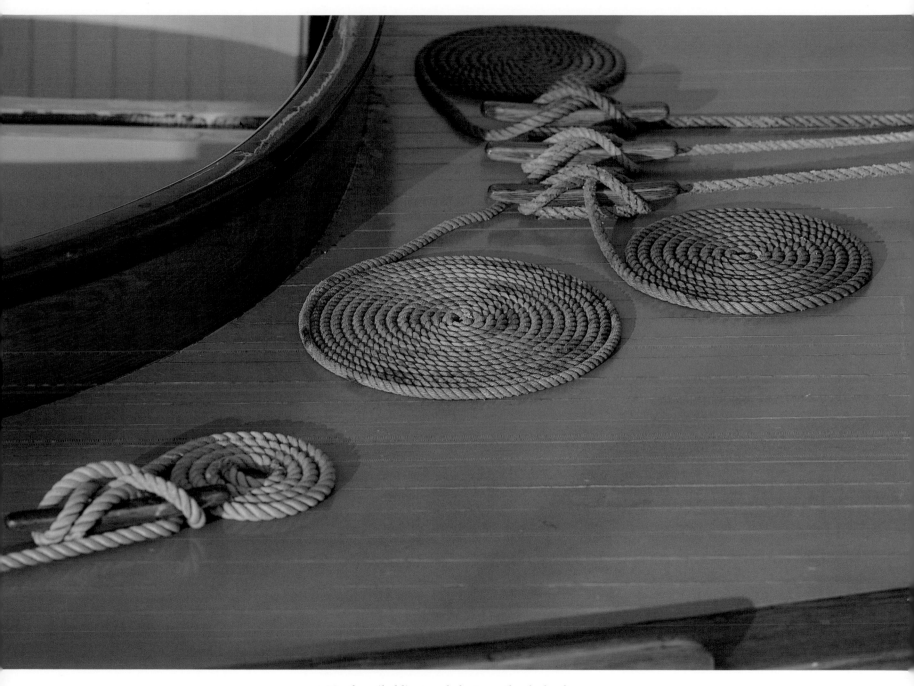

▲ Neatly coiled lines and cleats on the deck of a
sailing yacht moored at Connecticut's Mystic Seaport
paint a peaceful picture of seagoing life. Mystic's
involvement in all things marine has changed
over the years, but never diminished.

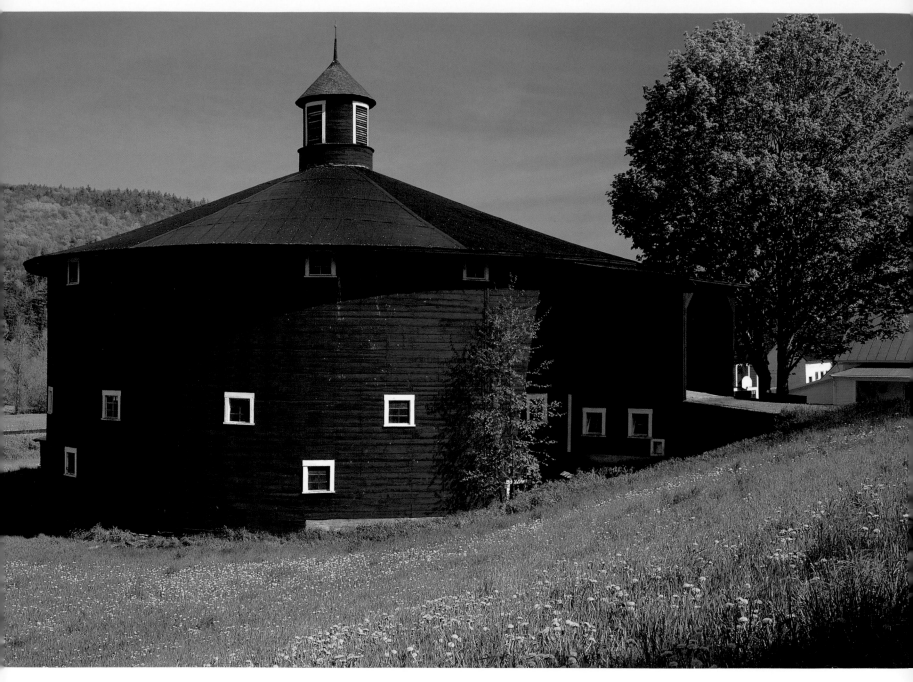

▲ Built in 1899 in East Barnet to house 100 cows, this
was the first round barn in Vermont. The round style was
intended to make feeding and milking the cows more efficient.
► Holsteins rest near a barn. Vermont dairy farmers export more than
90 percent of their milk, most to southern New England.
►► Fairlee, Vermont, is a small village nestled
in a bend of the Connecticut River.

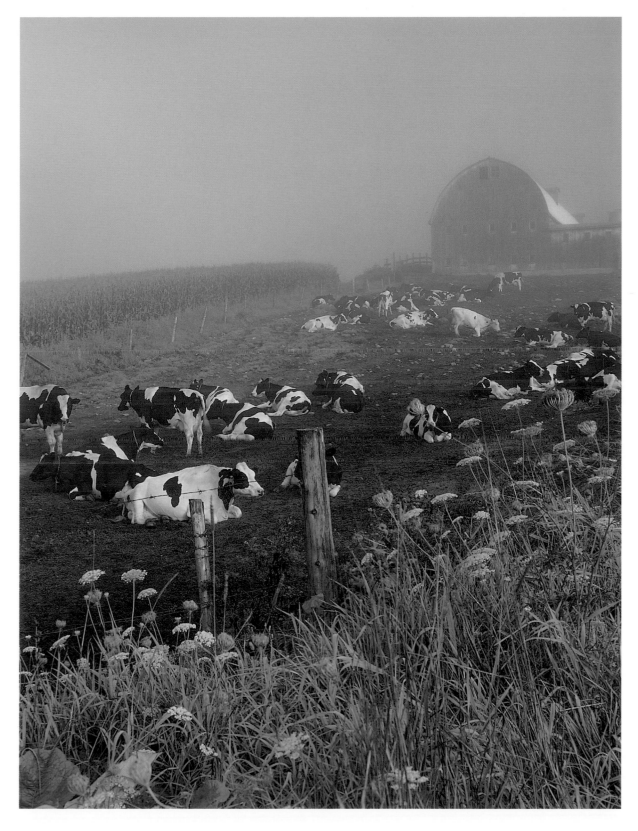

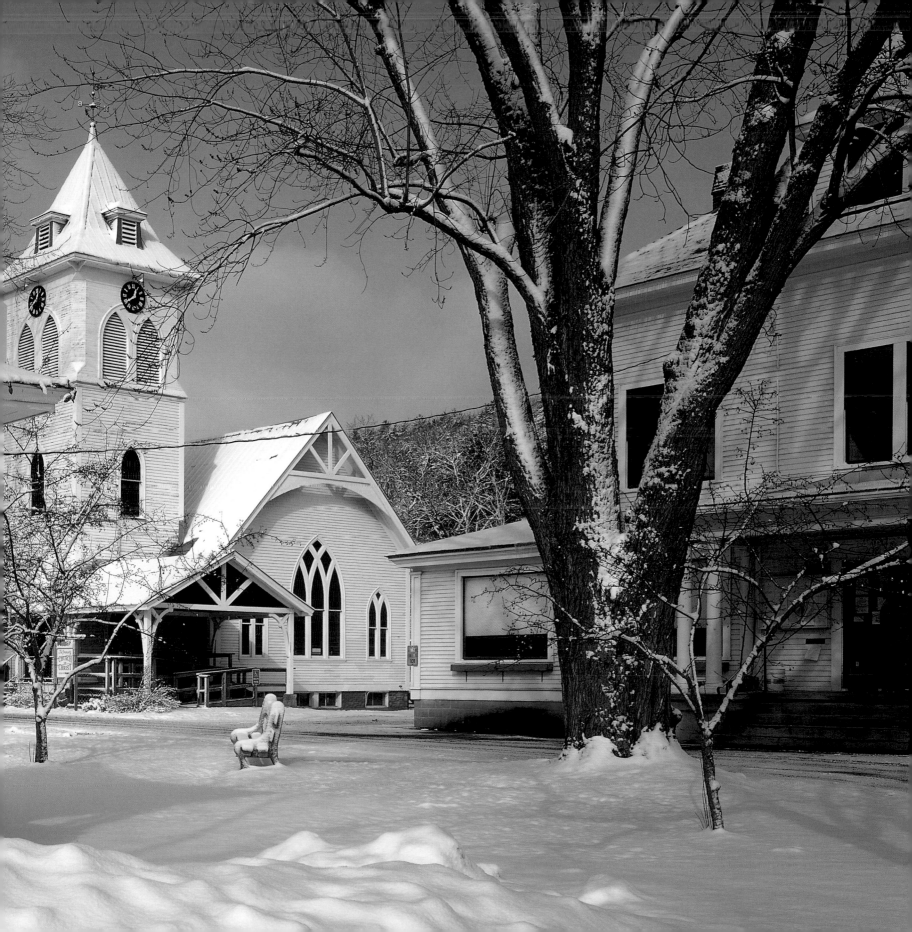

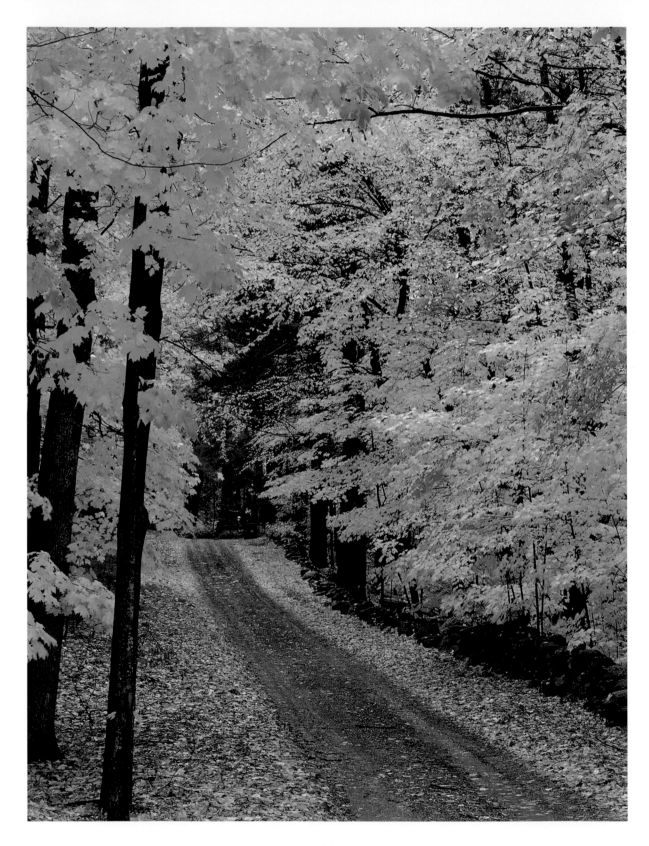

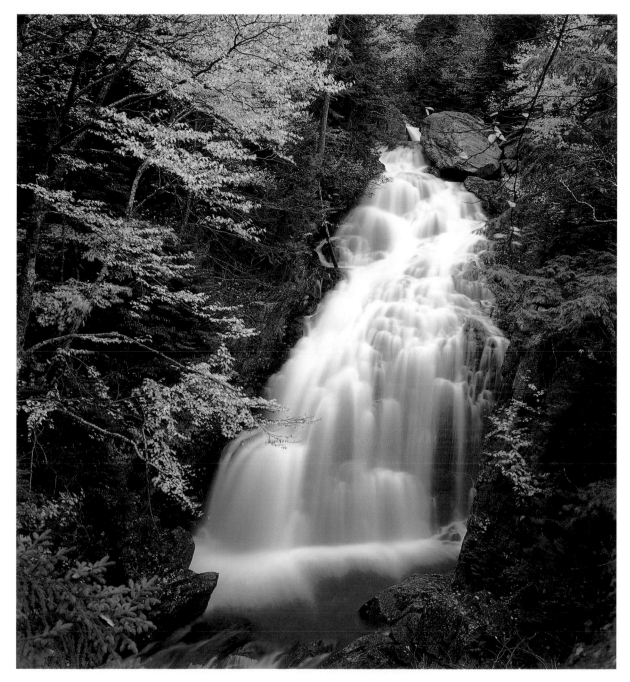

◄ A country lane near Hudson, Massachusetts,
leads deeper into New England's famous fall colors.
▲ Crystal Cascade, off Route 16 near Pinkham Notch,
New Hampshire, drops eighty feet in two drops.

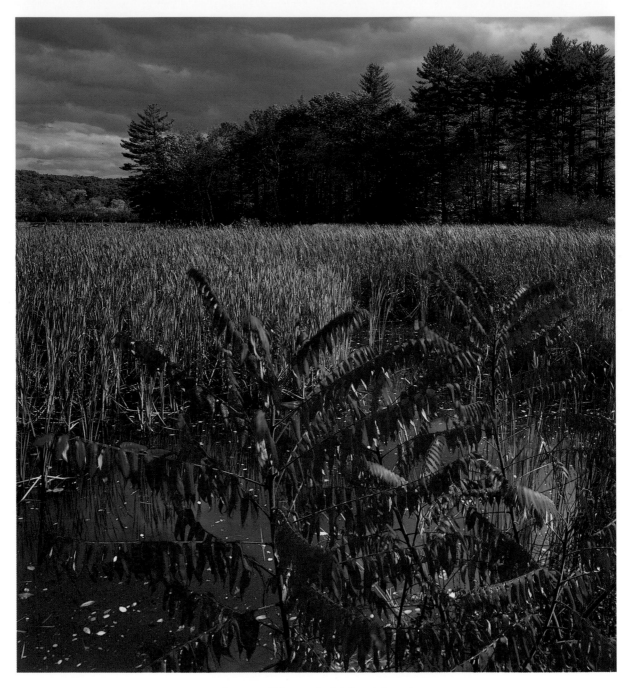

▲ Sumacs *(Rhus coriaria)* flourish at the
edge of a cattail swamp near Brattleboro, Vermont.
Brattleboro is a year-round resort area
set in an agricultural region.

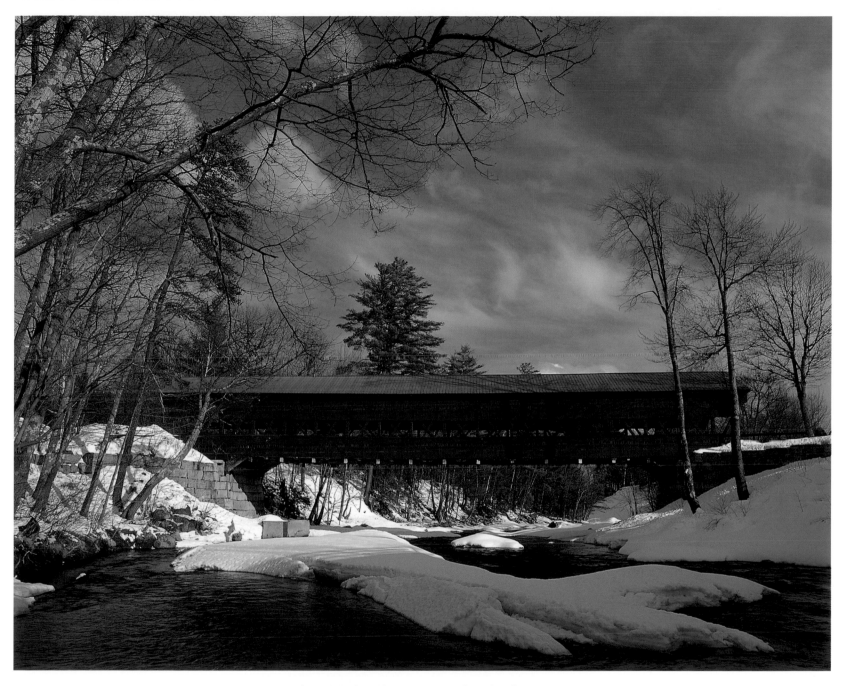

▲ The original Swift River Covered Bridge, located in
Conway, New Hampshire, was built in 1850. In 1869, a raging
flood sent it downriver where it destroyed the Saco River Covered
Bridge. Much of the lumber from the two bridges was salvaged
to build the present Swift River Bridge, constructed in 1870.

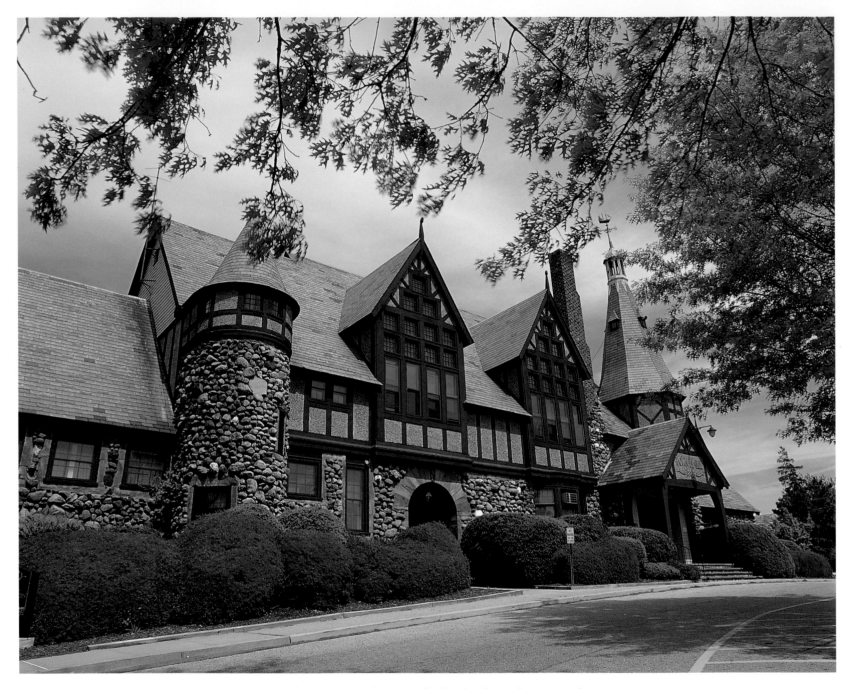

▲ In the 1600s, Barrington, Rhode Island, was known as the
"garden of the colony" because of its rich soil and scenic location.
Azaleas outside the Barrington Town Hall still show that fertile heritage.
▶ Situated at the Vineyard Haven entrance to Martha's Vineyard in
Massachusetts, the East Chop Lighthouse was constructed in 1878.
▶▶ A heritage of colonial farming efforts, a stone wall meanders
through the woods near Woodstock, Connecticut.

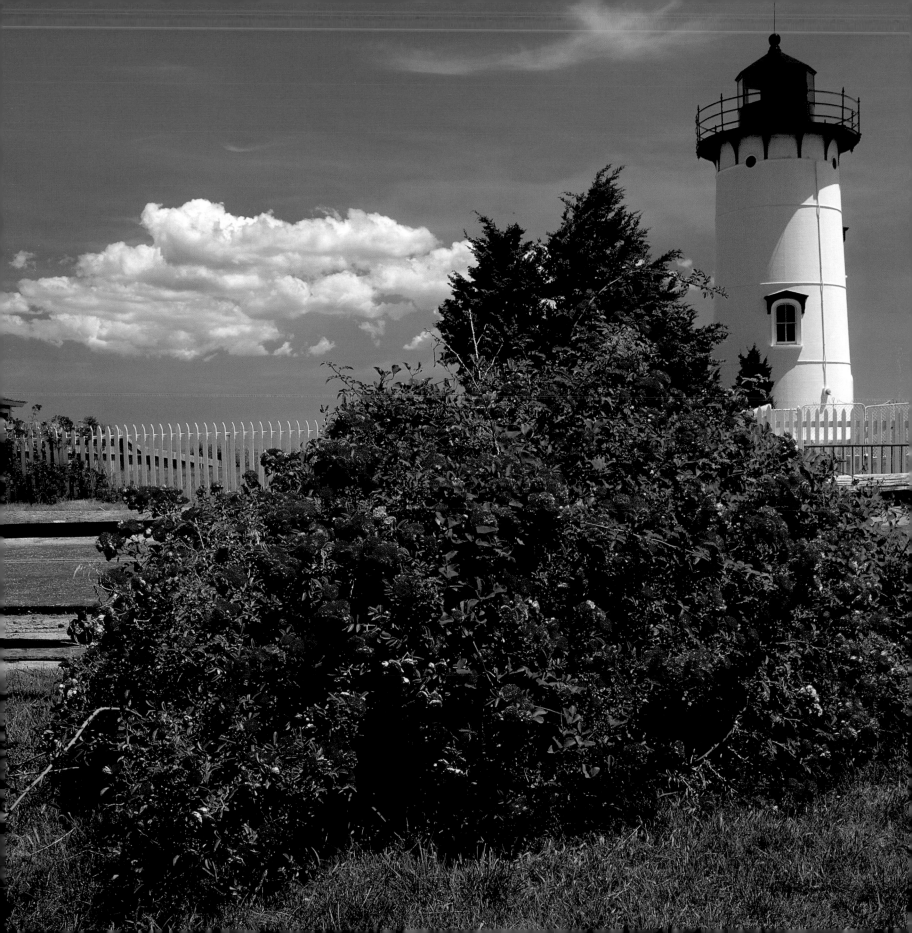

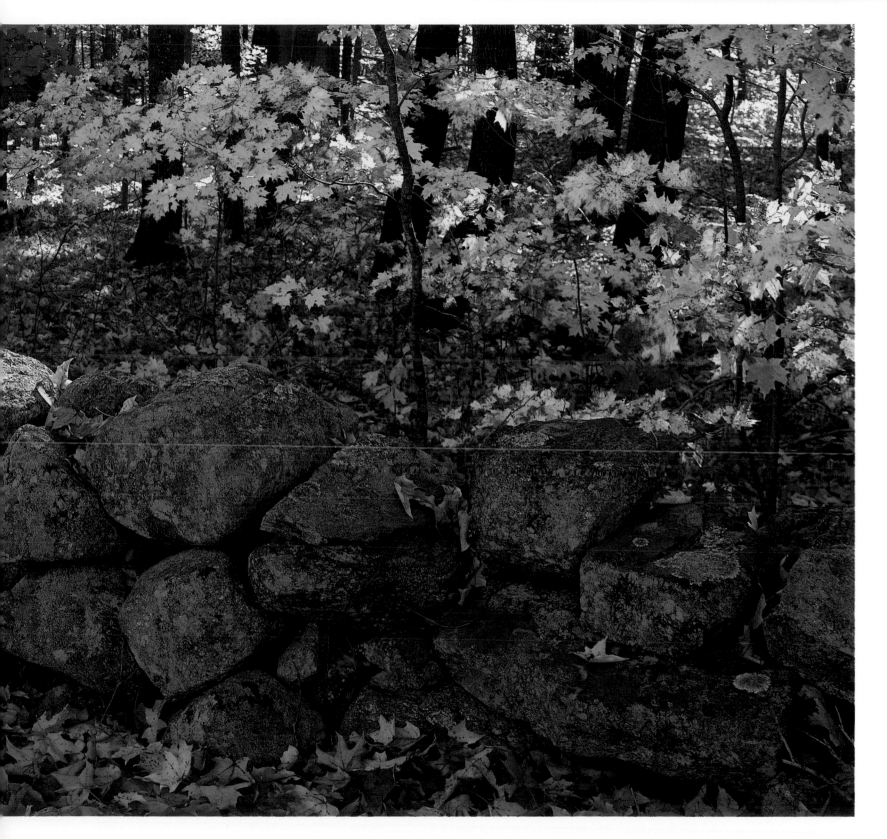

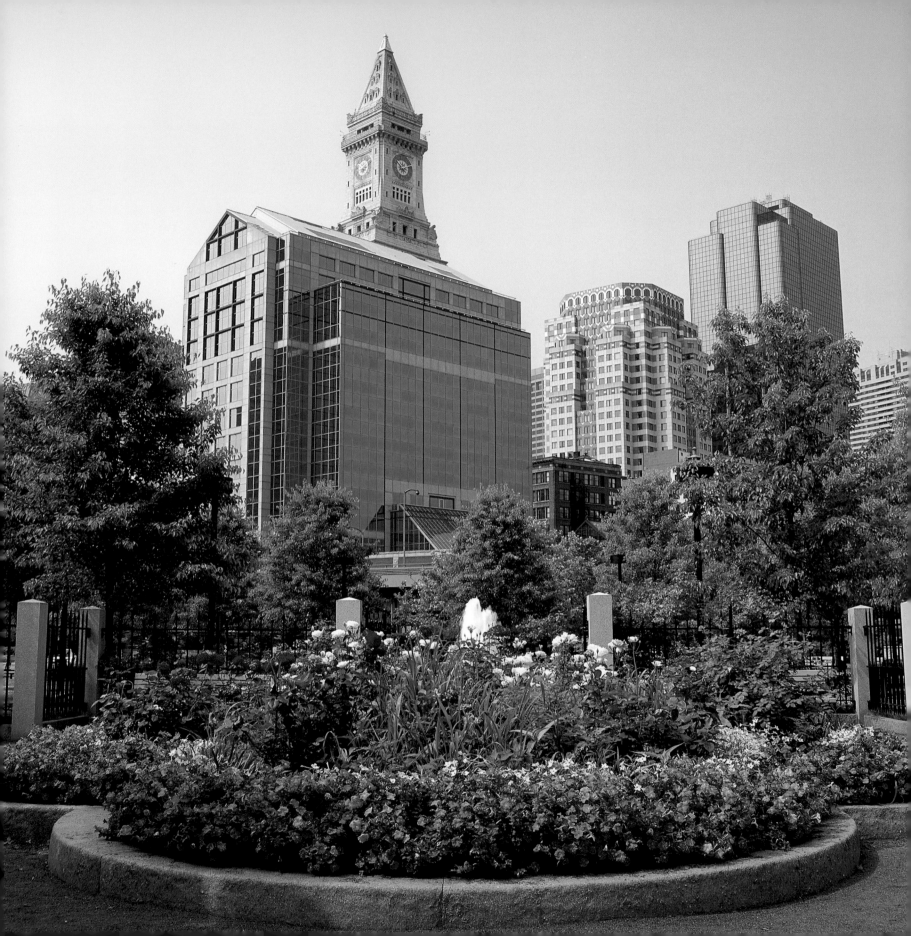

◄ The one-acre Rose Kennedy Garden overlooking
the Boston Harbor in Massachusetts is dedicated to Rose
Fitzgerald Kennedy, mother of the dynasty that includes the
late President John F. Kennedy, our nation's thirty-fifth president.
▲ Brightly colored plantings at White Flower Farm, a family-
owned nursery situated in Litchfield, Connecticut,
show some of the farm's variety.

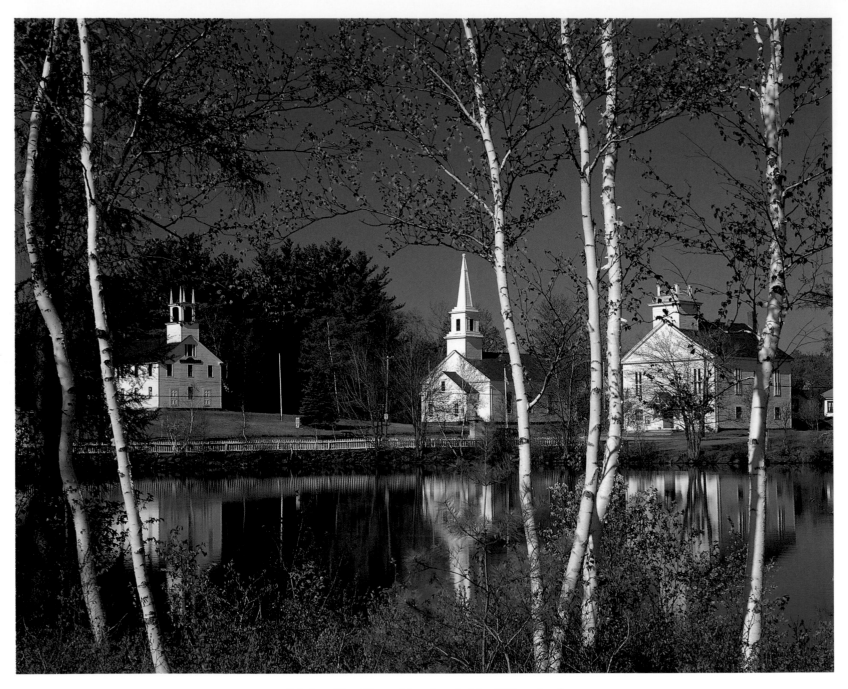

▲ Marlow, New Hampshire, founded in 1753 under the
name Addison, acquired its present name in 1761. Although there are
rumors that the town was named for the English poet Christopher Marlowe,
it seems more likely that it was named after the English town of Marlowe. Today,
Marlow, a classic example of a Yankee rural village, boasts a population of 747.
The village center with its white church, Odd Fellows Hall, Town Hall,
and lily pond is considered one of New England's most picturesque.

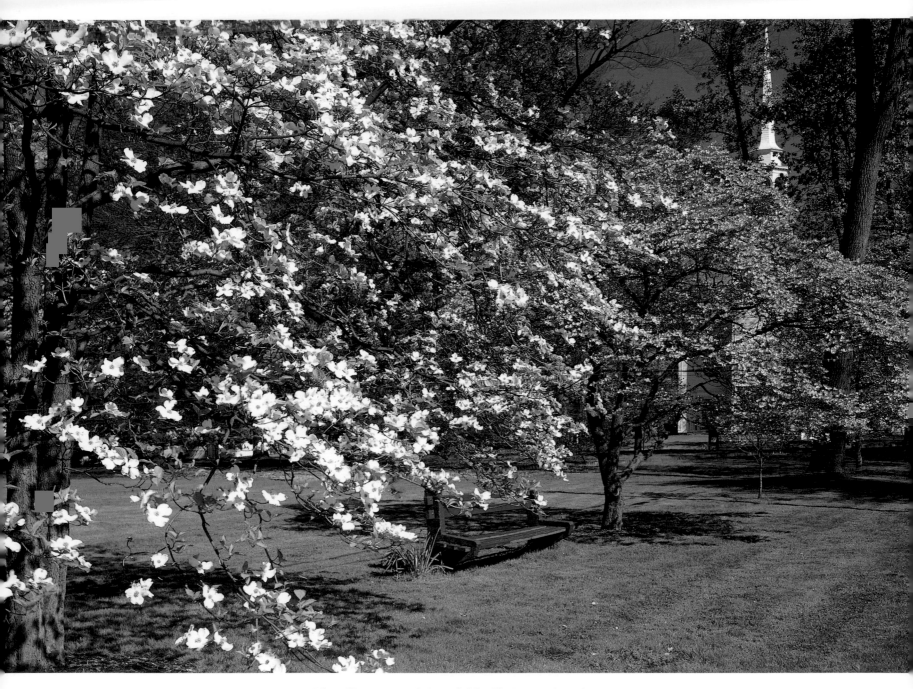

▲ The village green of Greenfield Hill, Connecticut, is
marked by dogwoods in bloom. A church steeple rises in the
background. Just an hour north of New York City, Greenfield Hill's shady
lanes and winding stone walls take one back to centuries-old rural life. Established
in 1725, this once-agrarian community has metamorphosed into one working
farm and a horse stable that offers riding lessons. The remaining barns and
pastures now have more high-tech uses but retain their rural look.

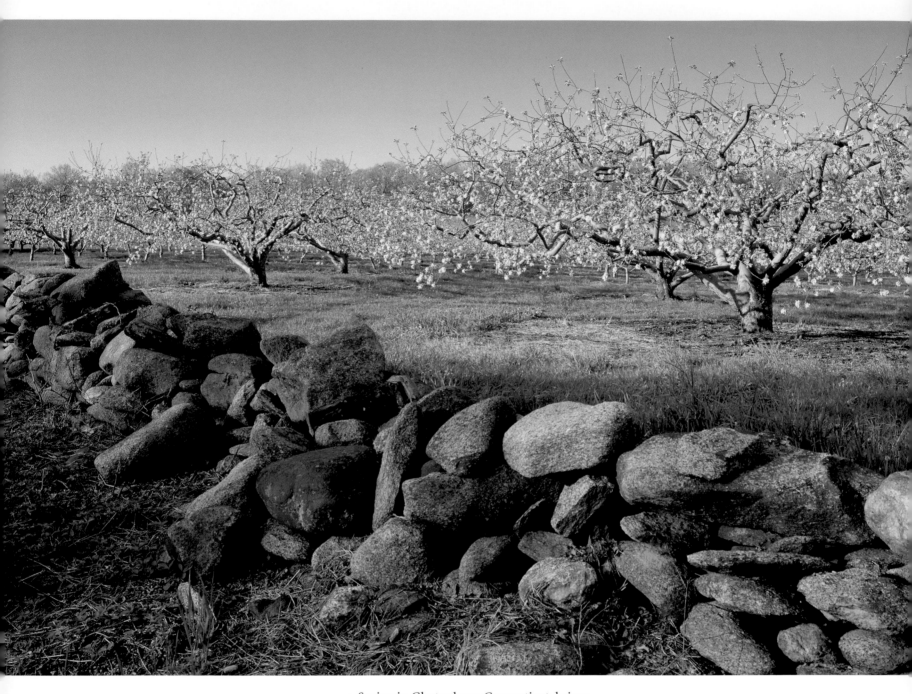

▲ Spring in Glastonbury, Connecticut, brings
an orchard in bloom, guarded by a stone fence. The
colonists found a way to use all those rocks they took
out of the fields they wished to cultivate, so such stone
fences are found today in many places—sometimes
logical through today's eyes, sometimes not.

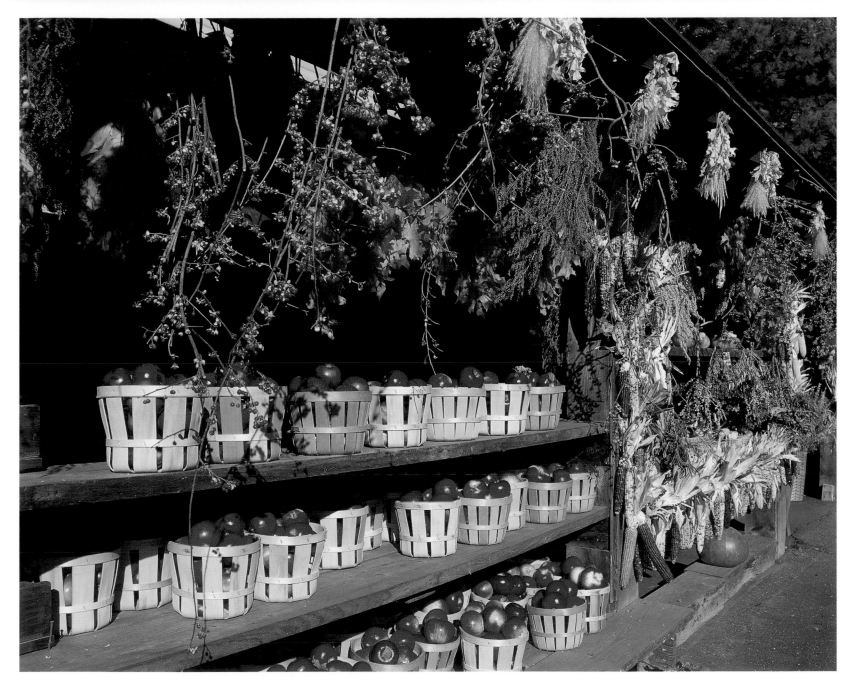

▲ Apples add bright color to a farm stand
near Deerfield, Massachusetts. In 1704, the French and
Indians burned much of the town, killing many settlers and
taking 112 captives back to Canada. The town's early economy
was based on tobacco, pickles, and pocketbooks. It is now
regarded as a tourist, industrial, and residential area.

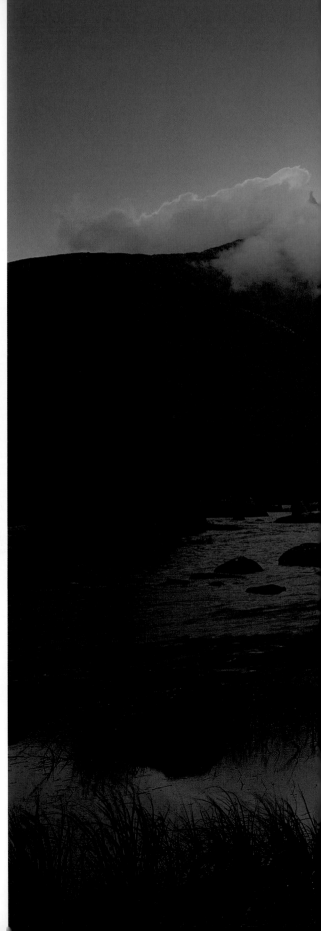

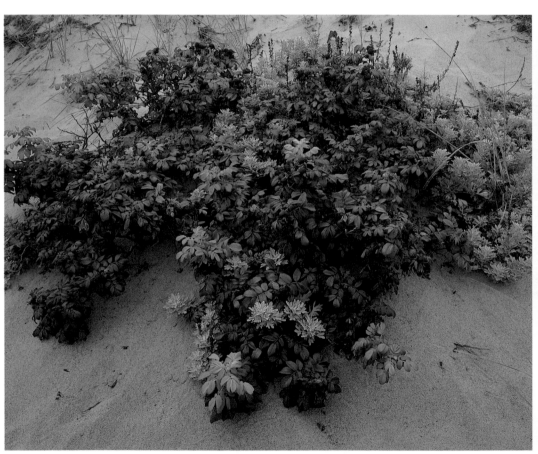

▲ A rose bush with hips, mixed with dusty miller *(Senecio cineraria)*,
flourishes on a sand dune at Cape Cod National Seashore, Massachusetts.
► Clouds cover 5,200-foot Mount Katahdin, Maine's highest mountain, in
Baxter State Park. Founded in 1931, the park's mandate then and
now is to ensure that "Katahdin in all its glory forever shall
remain the mountain of the people of Maine."

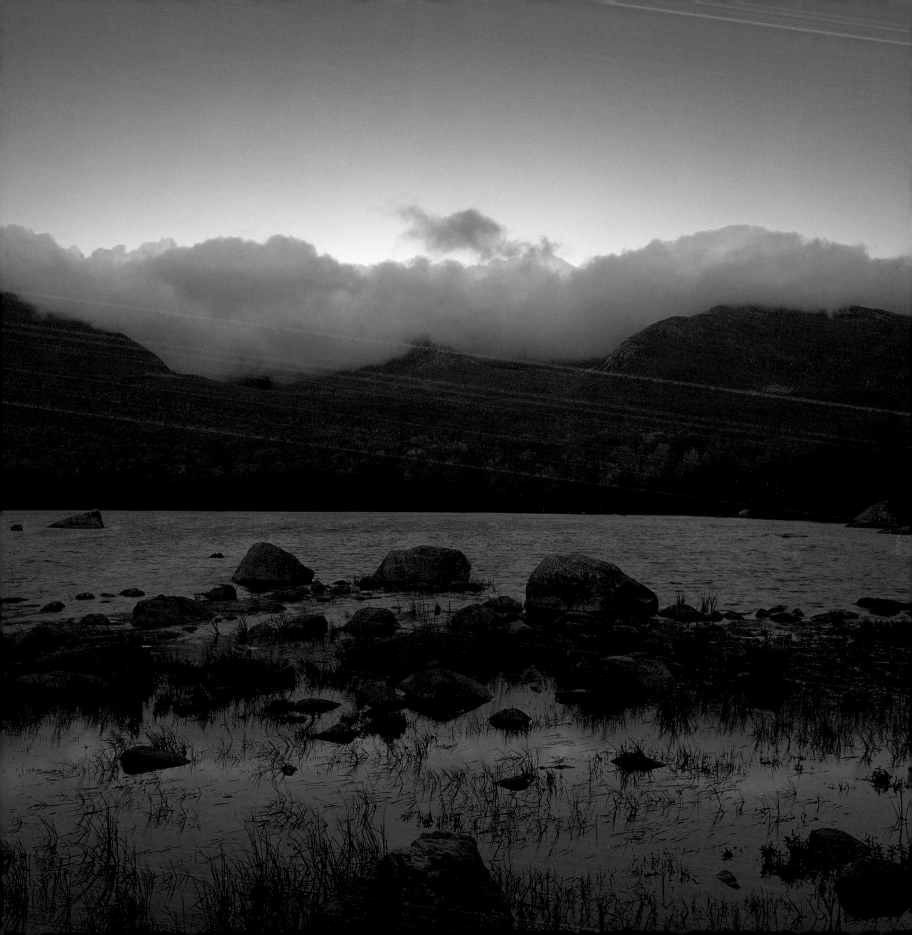

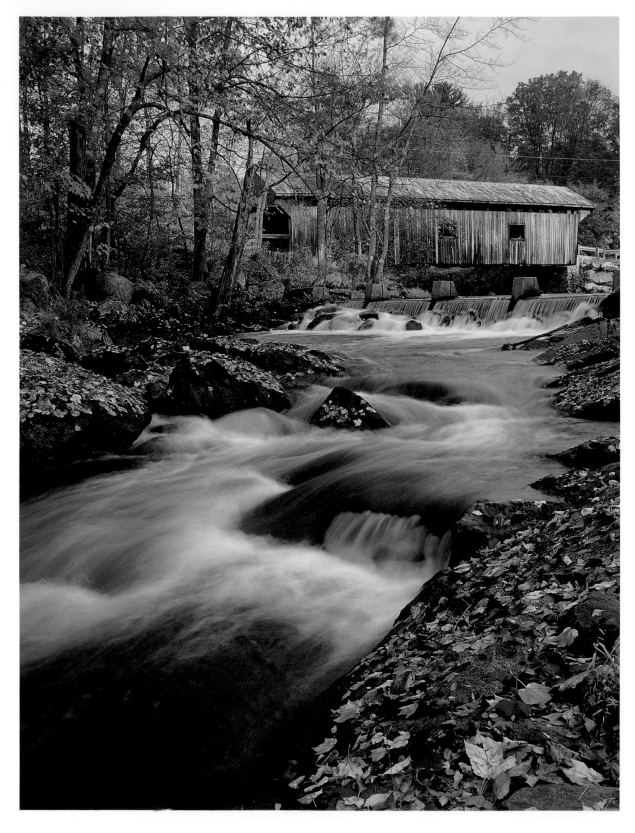

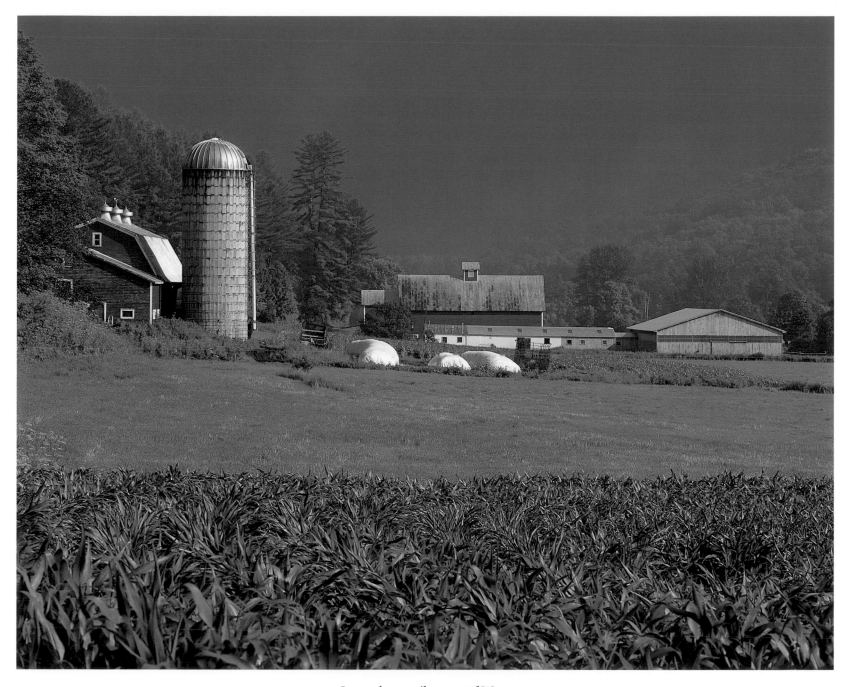

◄ Located two miles west of Warner
Village, New Hampshire, the seventy-six-foot-long
Waterloo Covered Bridge was constructed in 1840 and
rebuilt three times since then—in 1857, 1970, and 1987.
▲ A barn and silo complex nestles beneath a stormy sky
in Strafford, Vermont. Chartered in 1761, the
town is named for the Earl of Strafford.

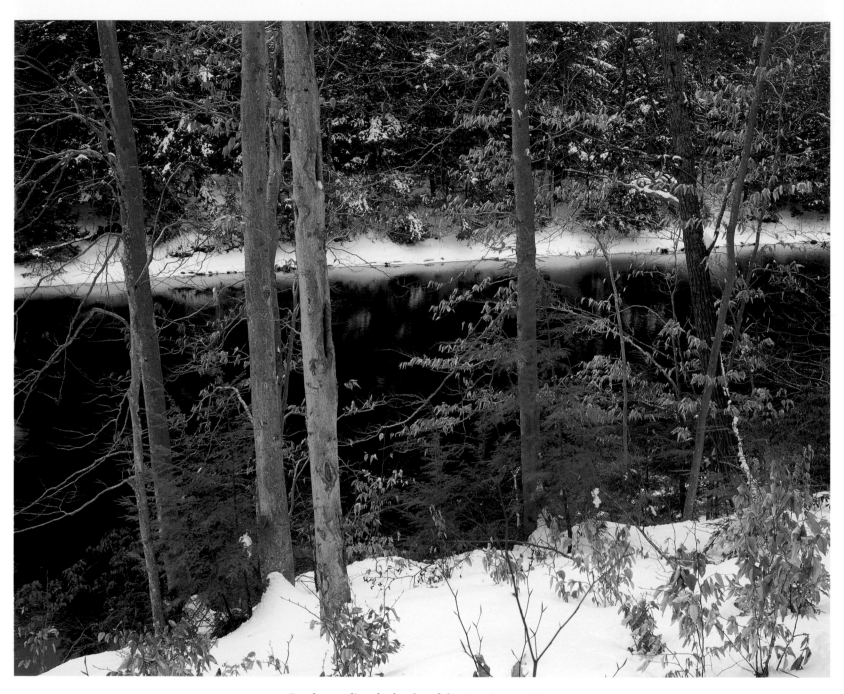

▲ Beech trees line the banks of the Farmington River
in the Peoples State Forest near Barkhamsted, Connecticut.
The forest offers fishing, hunting, and winter sporting
activities, all surrounded by wooded splendor.

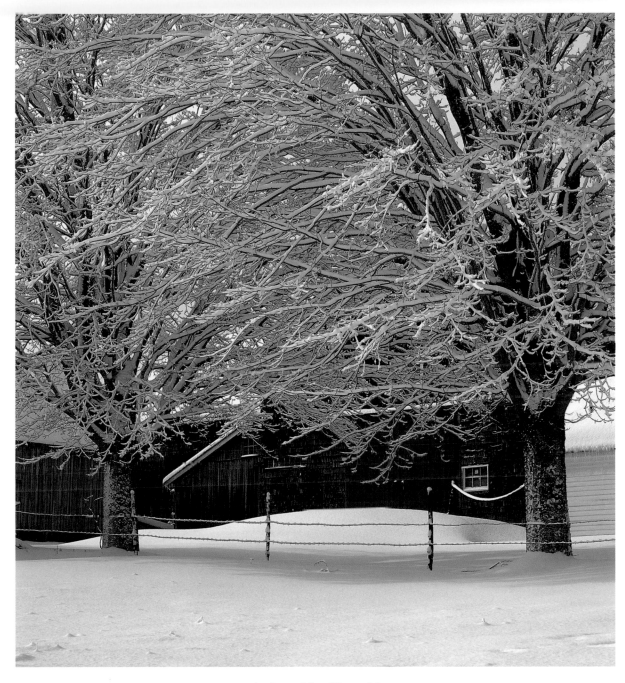

▲ Andover, New Hampshire,
shows a clean face after a snowstorm.
A town of some 2,000 residents, the name
comes from Andover, Massachusetts.

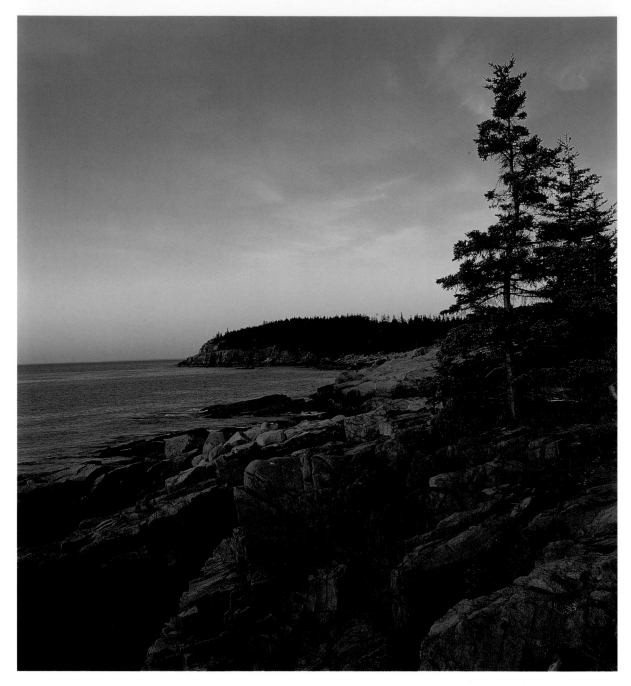

▲ Spruce trees rise from a granite shoreline
along the Atlantic Coast in Acadia National Park, Maine.
Acadia encompasses more than 47,000 acres of granite-domed
mountains, woodlands, lakes, ponds, and ocean shoreline.
► Wallingford, Vermont, is unusual in that almost all of its
topographical features have descriptive names—
such as Conical Peak, shown here.

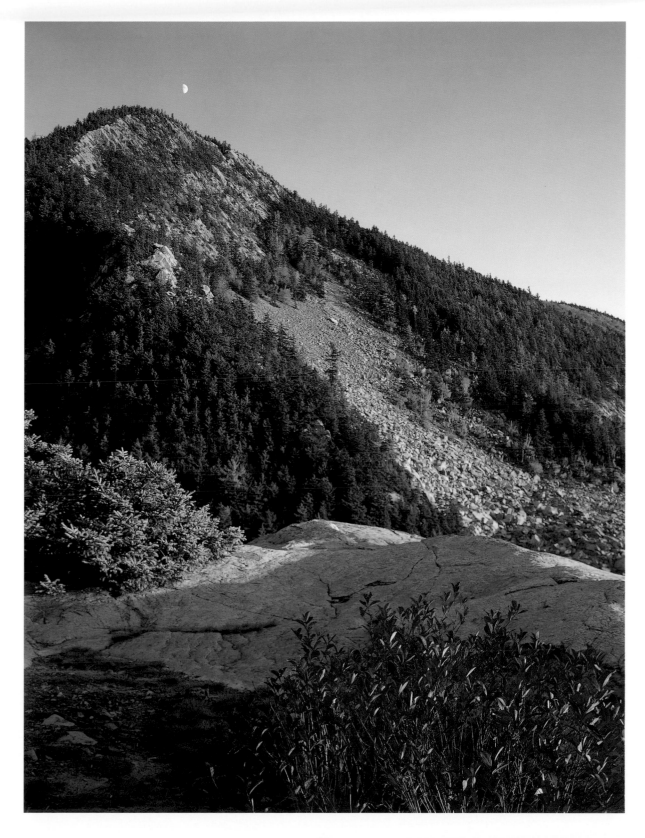

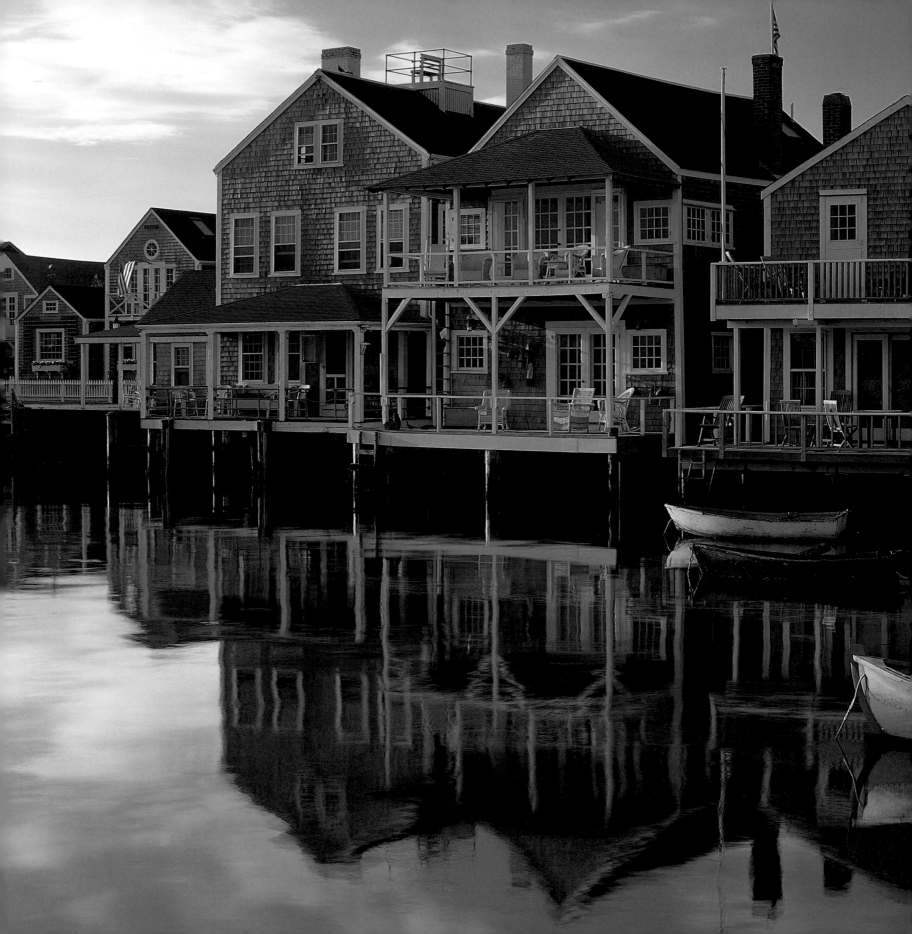

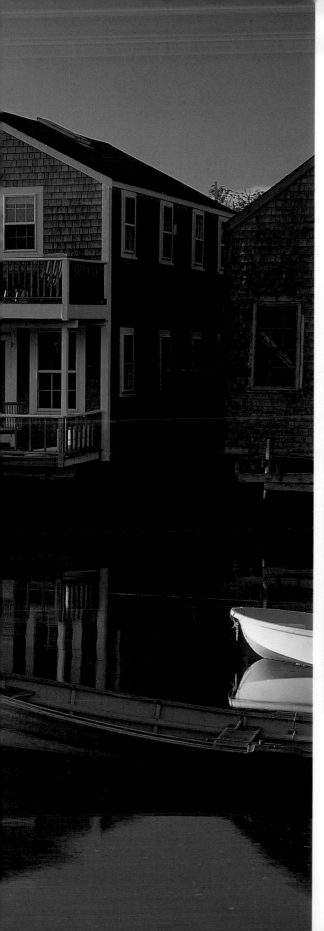

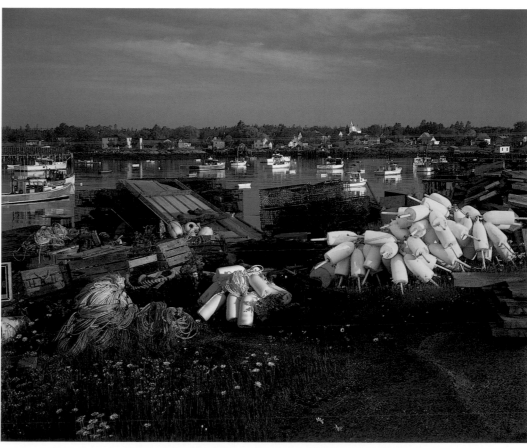

◄ Restored boat houses characterize Old North Wharf,
now a residential wharf on Nantucket Harbor, Massachusetts.
▲ Fishing gear is interspersed with wildflowers, boats, and homes in the
village of Corea, Maine, the quintessential lobstering port,
home to a fleet of some forty lobster boats.

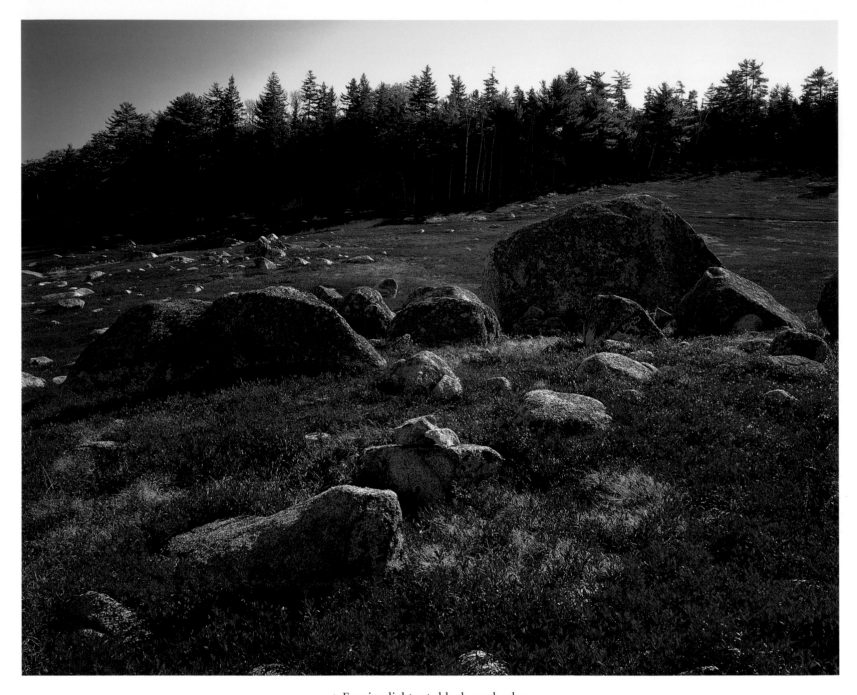

▲ Evening light sets blueberry bushes
ablaze on boulder-covered Blue Hill in Maine.
► Outlined by autumn leaves, a cascade marks the
headwaters of the West Branch of the White River, in
Vermont's Green Mountain National Forest.

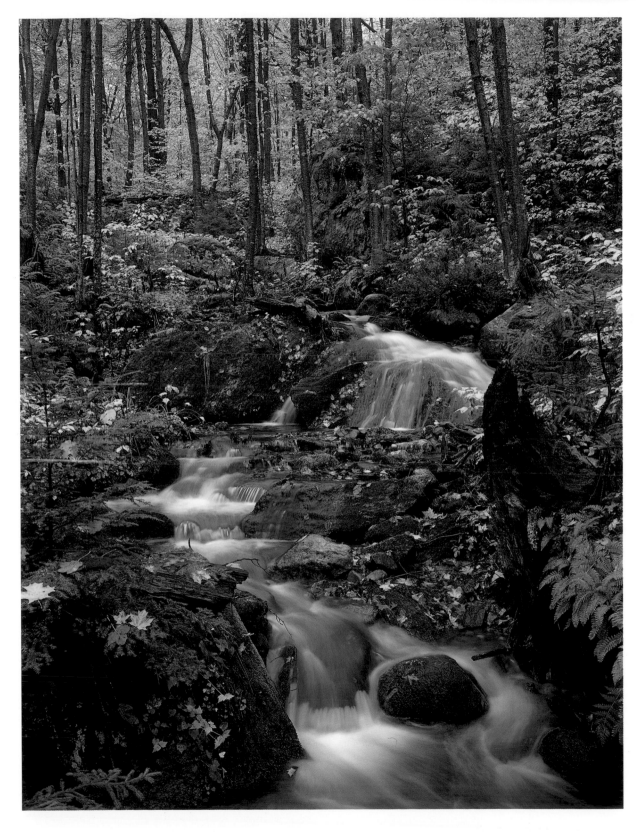

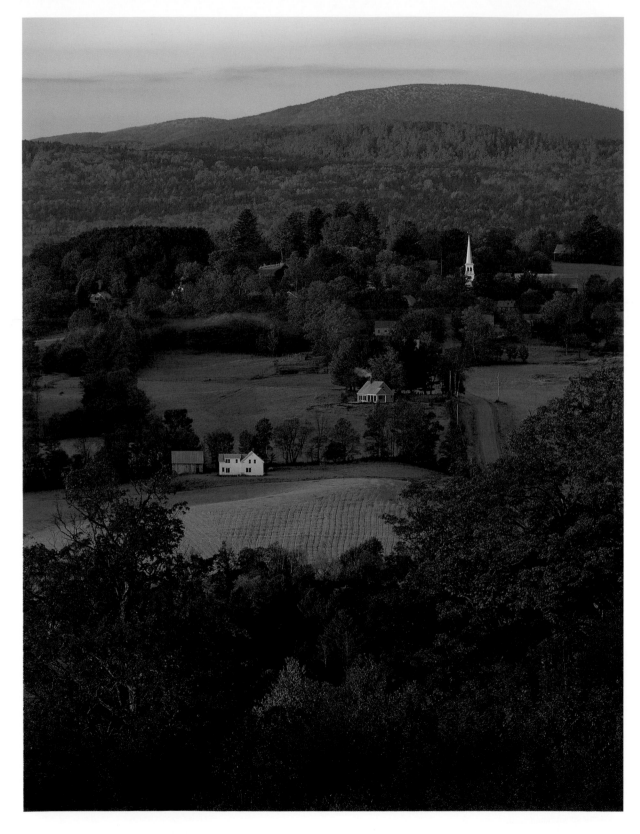

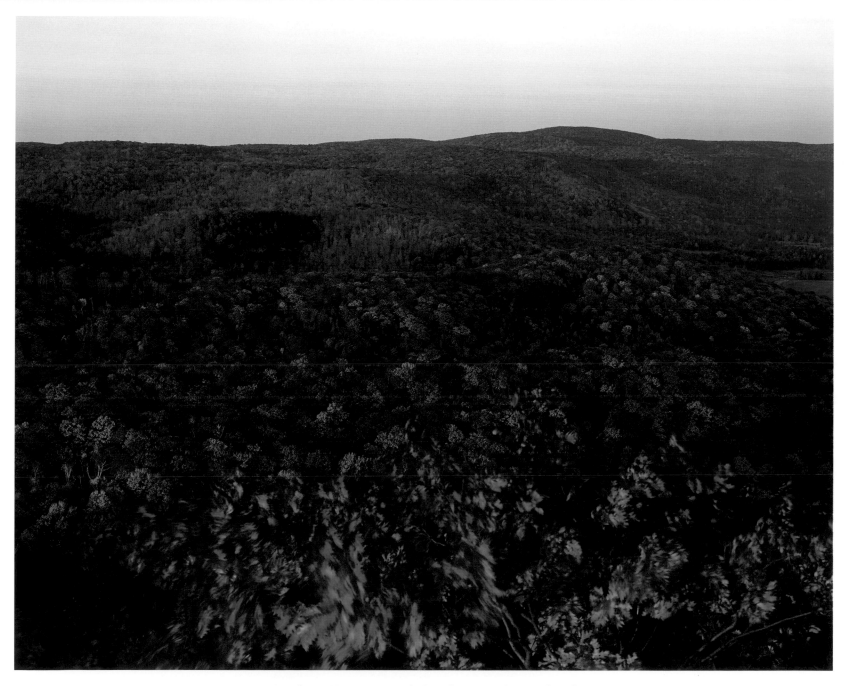

◄ Peacham, Vermont, population about 700, is touted as the
most-photographed town in New England. Peacham Academy, the third
county grammar school in Vermont, was chartered in 1795. The school closed in 1971.
▲ The Litchfield Hills, in Haystack Mountain State Park in Connecticut's
northwest corner, are a favorite getaway for New Yorkers.

41

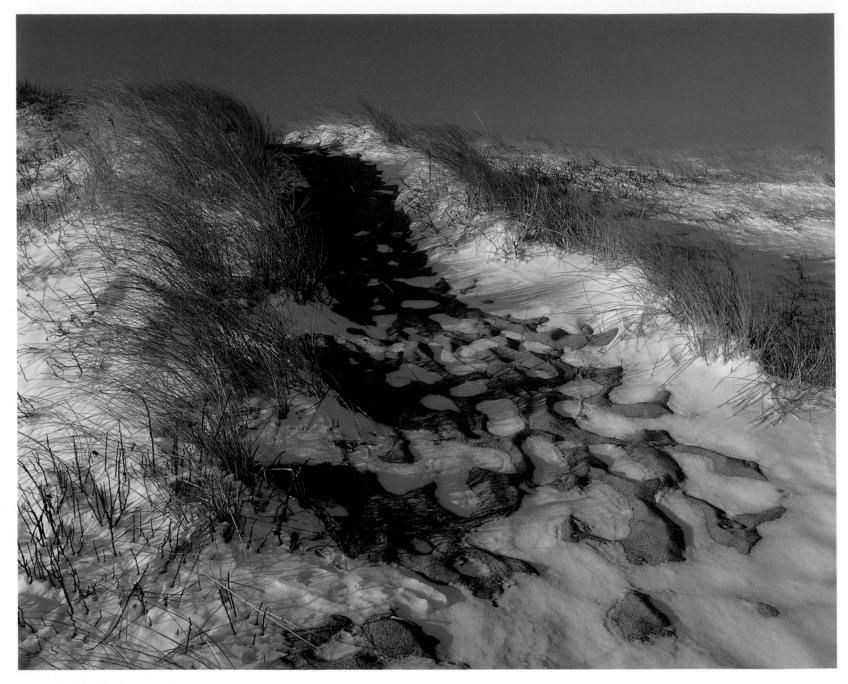

▲ Windblown grasses maintain
a fragile hold on a snow-covered dune
at Cape Cod National Seashore, Massachusetts.
Footprints in the snow show the way over the dune.
▶ At –10 degrees Fahrenheit, Owls Head, near
Jefferson, New Hampshire, rises to 4,025 feet.

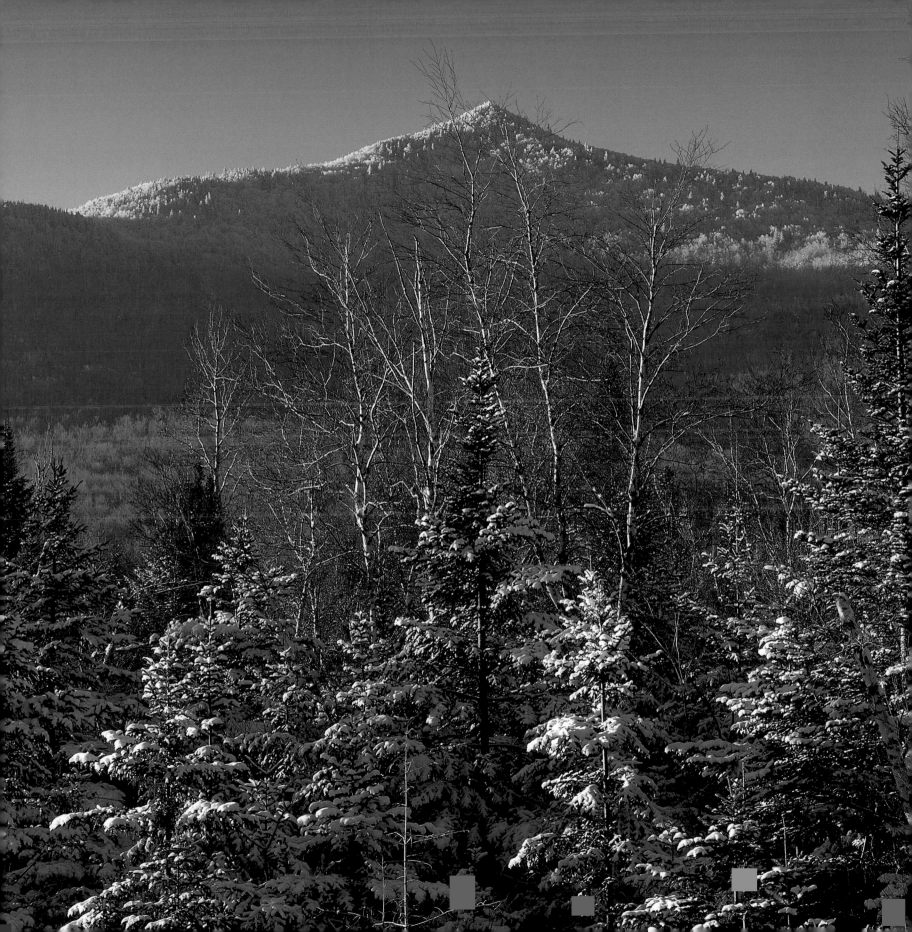

▲ A swamp in Piscataquis County, Maine, takes
on an ethereal mystique as frost touches everything
with magic. Piscataquis County is the state's least populated.
► In autumn maples and pines contrast each other in
Connecticut's 746-acre John A. Minetto State Park.

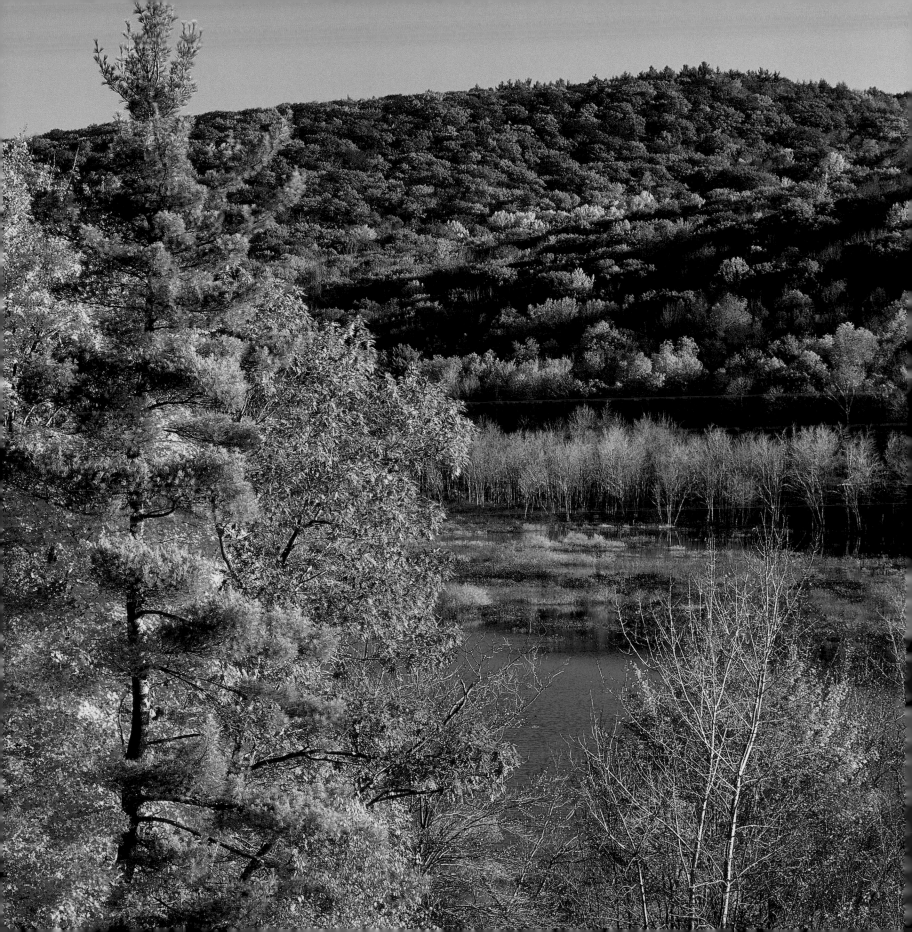

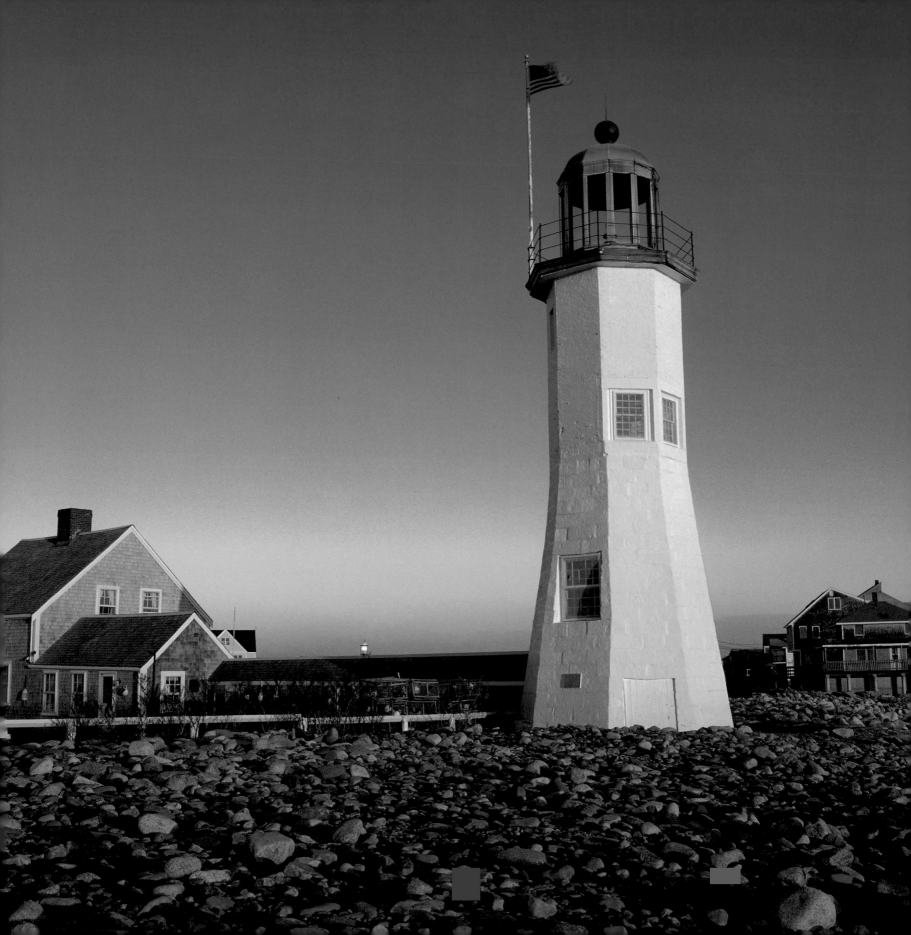

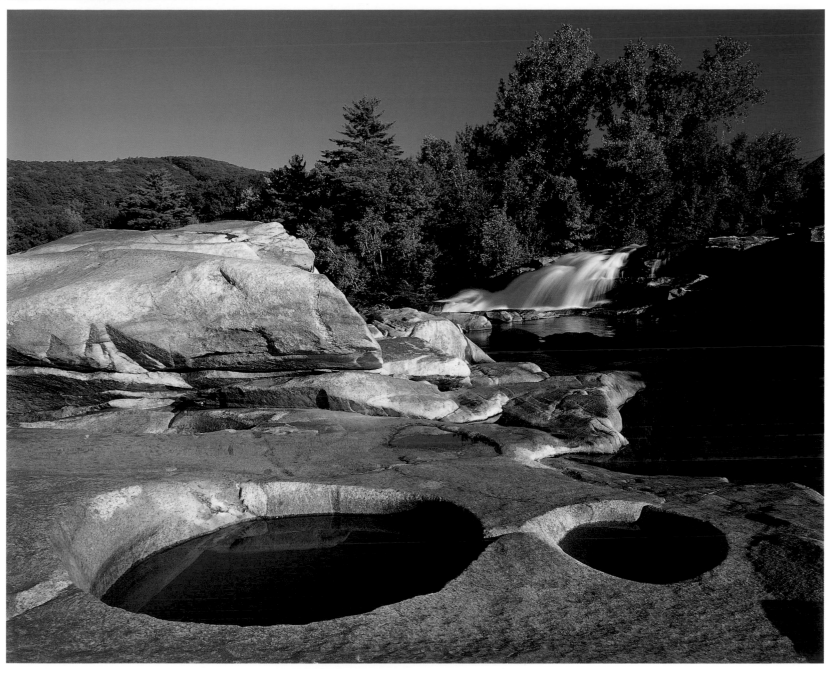

◄ The Scituate Lighthouse, constructed in 1811, was
deactivated in 1860. It was finally reactivated in 1990, again
warning seagoing vessels to avoid the rocky shore.
▲ Glacial potholes dot the area around the
Deerfield River in Massachusetts.

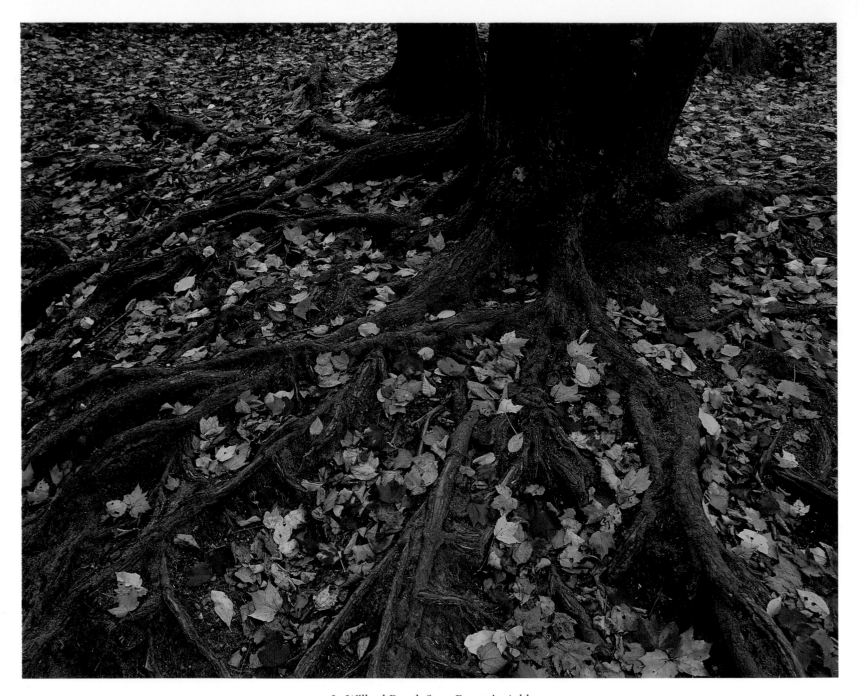

▲ In Willard Brook State Forest in Ashby
and Townsend, Massachusetts, a hemlock tree creates
interesting root patterns, marked by fallen red maple leaves.
▶ Connecticut's Tunxis State Forest encompasses large
areas of unbroken forest in and around the towns
of Hartland, Barkhamsted, and Granby.

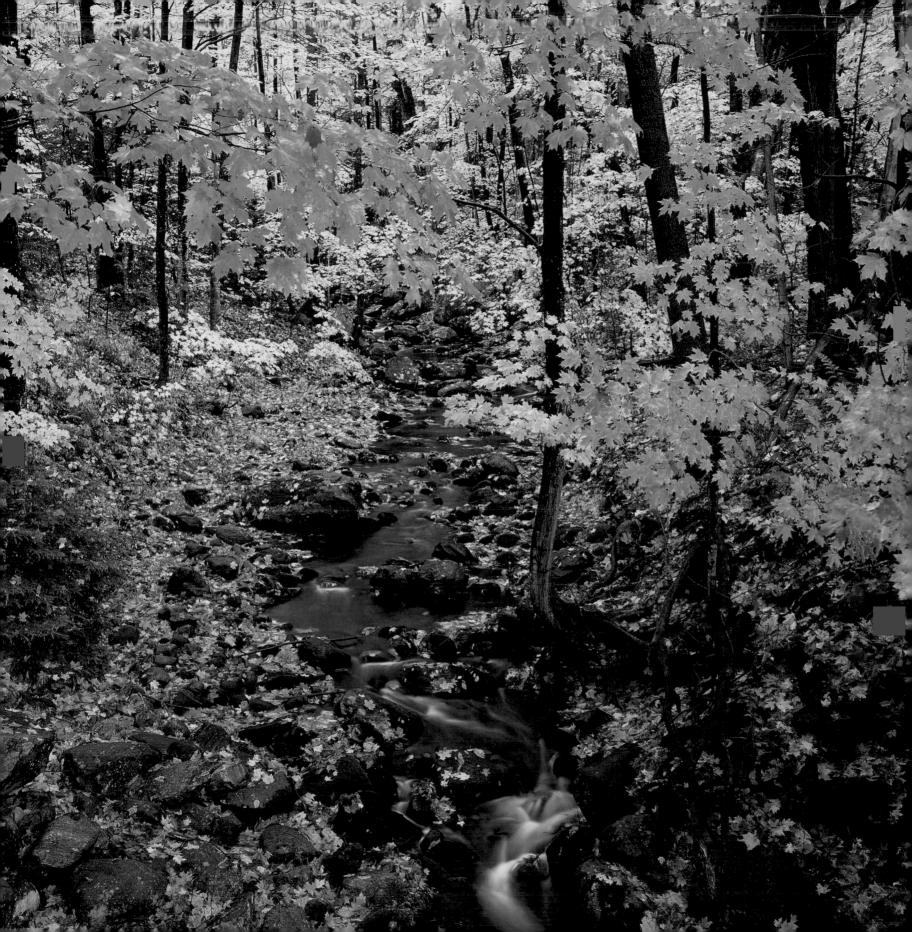

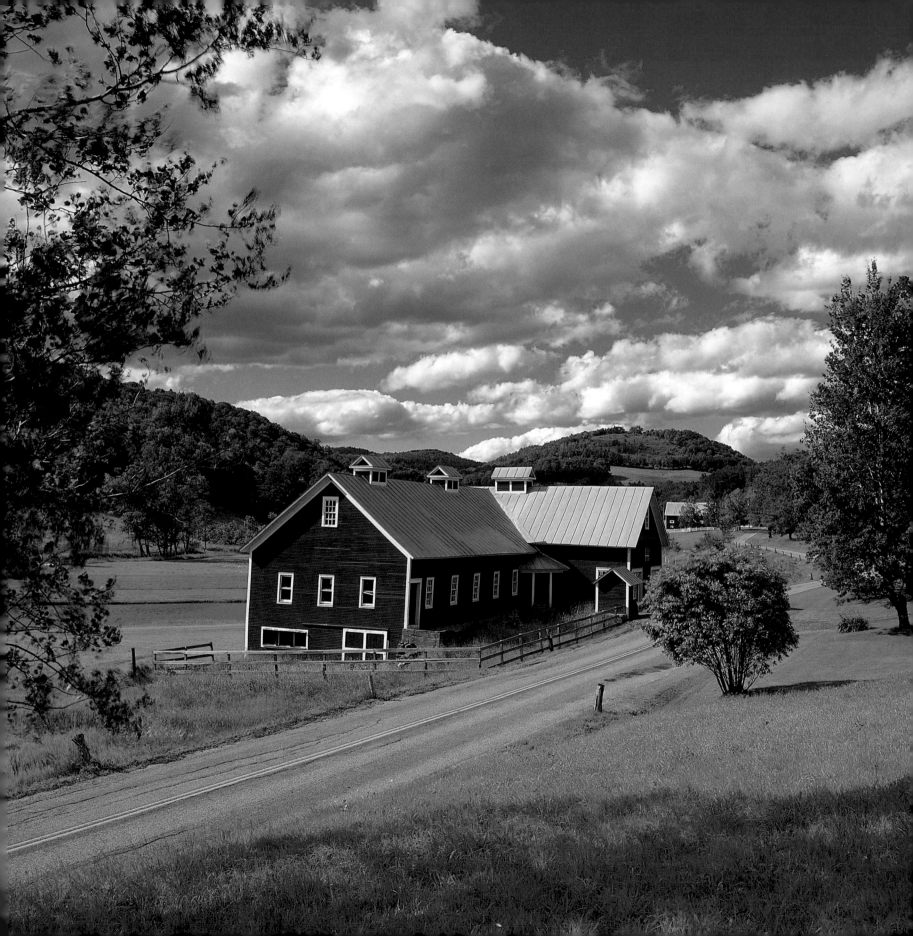

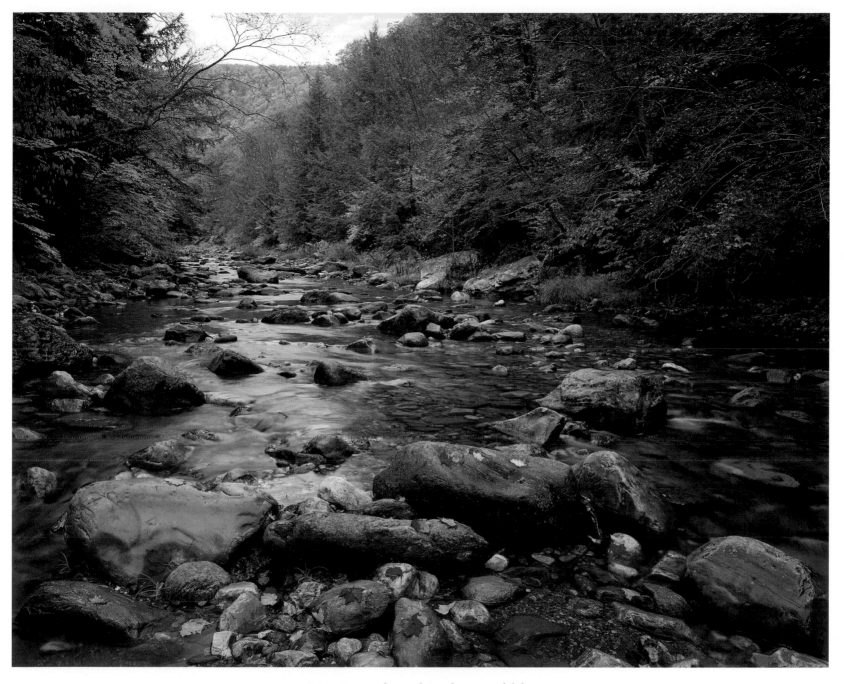

◄ A country road cuts through a peaceful farm,
complete with barns and a farm pond, near Pomfret, Vermont.
▲ Savoy Mountain State Forest, situated along the Mohawk Trail in
the northwest corner of Massachusetts, encompasses
some twenty miles of hiking trails.

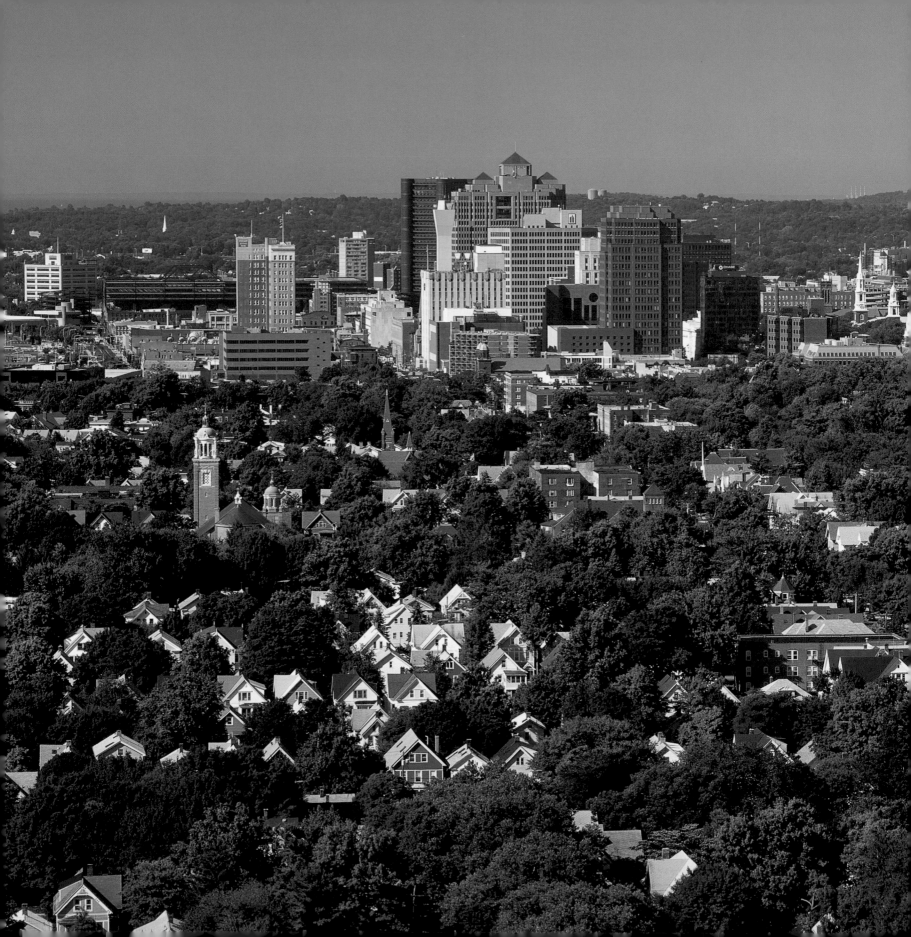

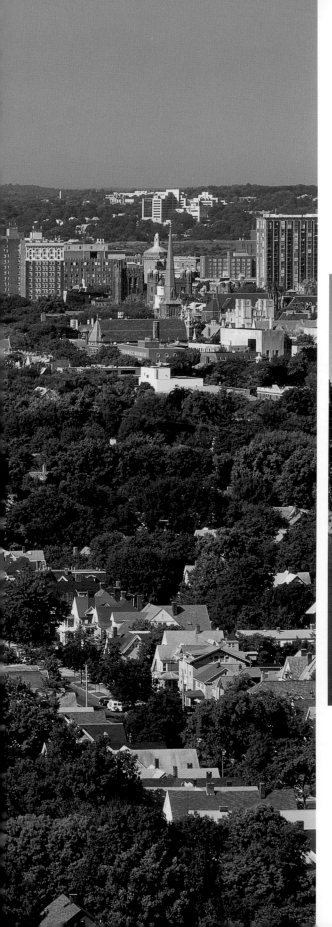

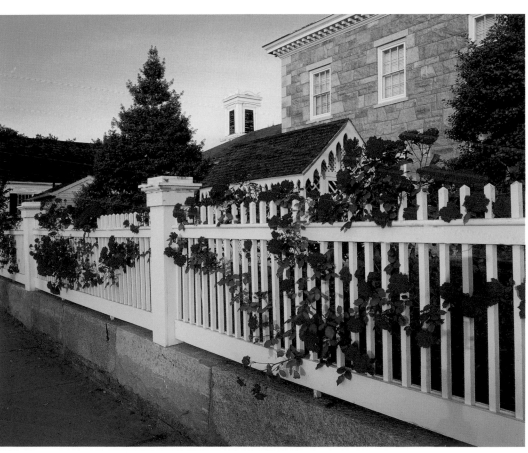

◄ New Haven, Connecticut, with a year-round population
of some 125,000, is home to Yale University, founded in 1701.
▲ Roses decorate a fence in Mystic Seaport. The seaport is known for its
Museum of America and the Sea, a living history museum consisting
of ships, a village, and seventeen acres of exhibits that depict
coastal life in nineteenth-century New England.

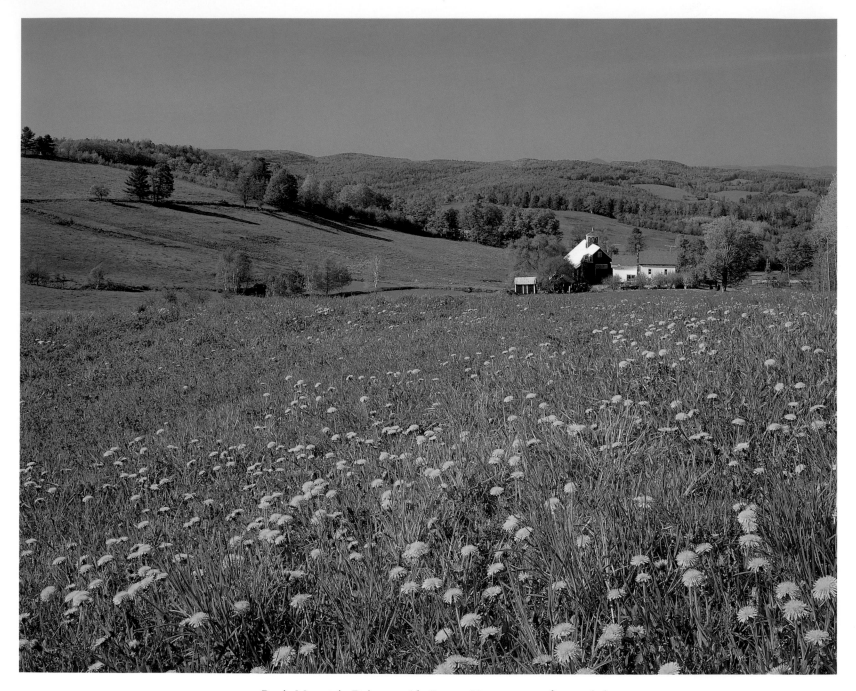

▲ Bogie Mountain Dairy, outside Barnet, Vermont, was first settled
around 1790 by Robert Blair. Until 1950, the land remained in the Blair family.
Now owned by the Bogies, it is an active dairy farm and also produces maple syrup.
▶ The Portland Head Light, at the tip of Cape Elizabeth, Maine, was first lit
on January 10, 1791—with sixteen whale oil lamps. Today, the U.S.
Coast Guard maintains its automated light and fog signal, but
the town of Cape Elizabeth manages the rest of the property.

54

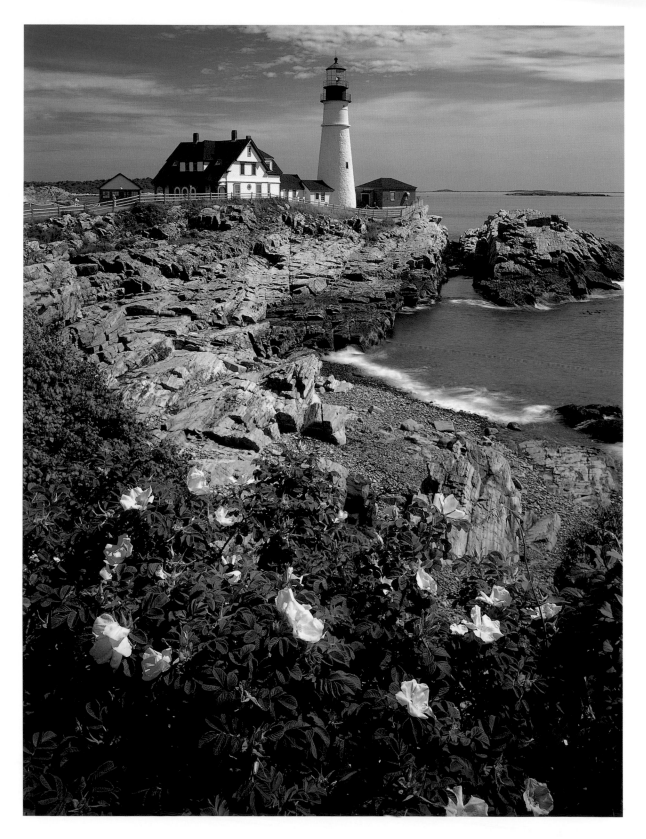

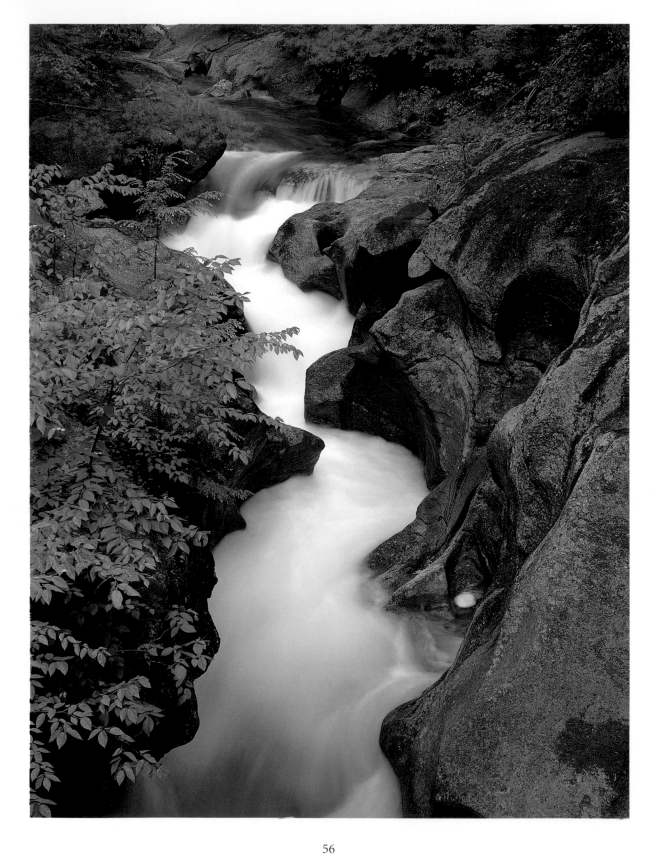

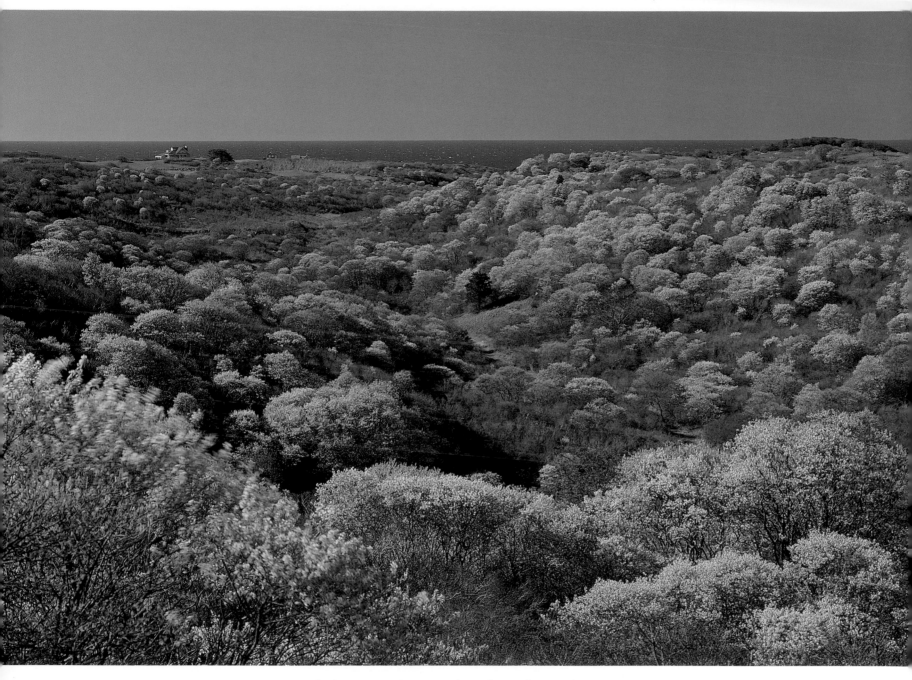

◄ As the last ice age drew to a close, the Cockermouth River
began to carve a narrow canyon in bedrock on its way to Newfound Lake.
Sculptured Rocks Natural Area, New Hampshire, is the result of that river artistry.
▲ Juneberry *(Amelanchier)* trees bloom at Rodman's Hollow on Block Island,
Rhode Island. Ranging from Newfoundland and Labrador across the
North American continent to the Gulf of Mexico, juneberry, also
known as shadbush or serviceberry, is a versatile, delicious berry.

57

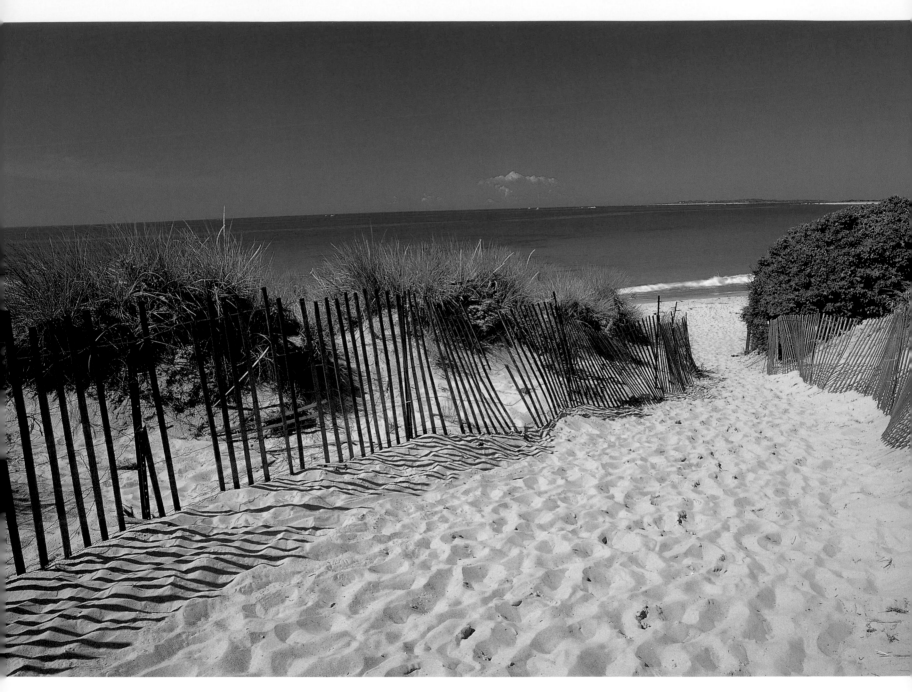

▲ At Napatree Beach on the Block Island Sound,
Rhode Island, dune fences encourage stabilization by
trapping wind-driven sand. When Roger Williams ran afoul of
the Puritan leadership in Massachusetts, he fled to what is now Rhode
Island, where he *purchased* land—rather than simply taking it as
was the usual custom—from the Narragansett Chiefs and
named his settlement Providence in thanks to God.

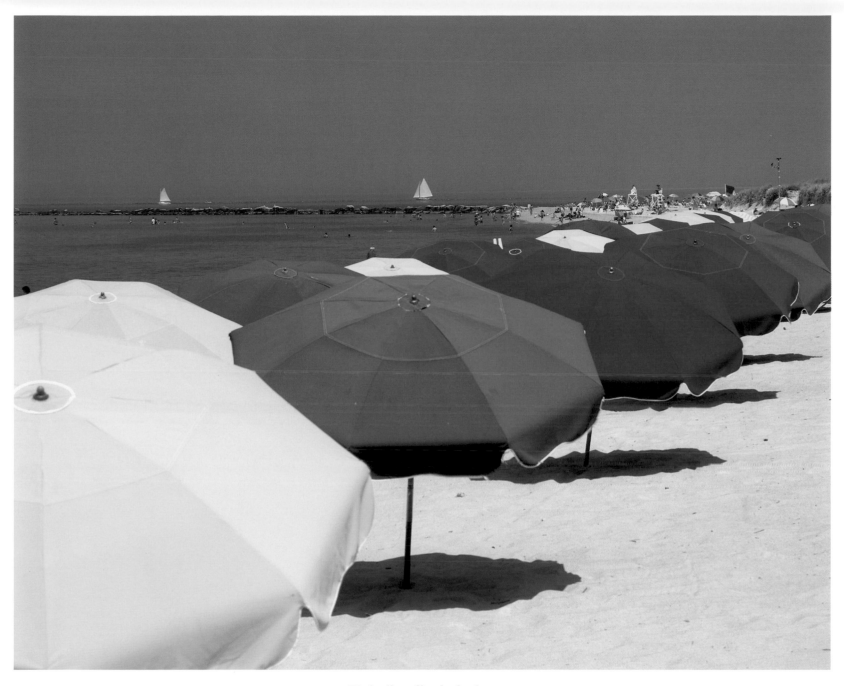

▲ Umbrellas offer shade along a
beach on Nantucket Island, Massachusetts. Most of
Nantucket's beaches are privately owned.

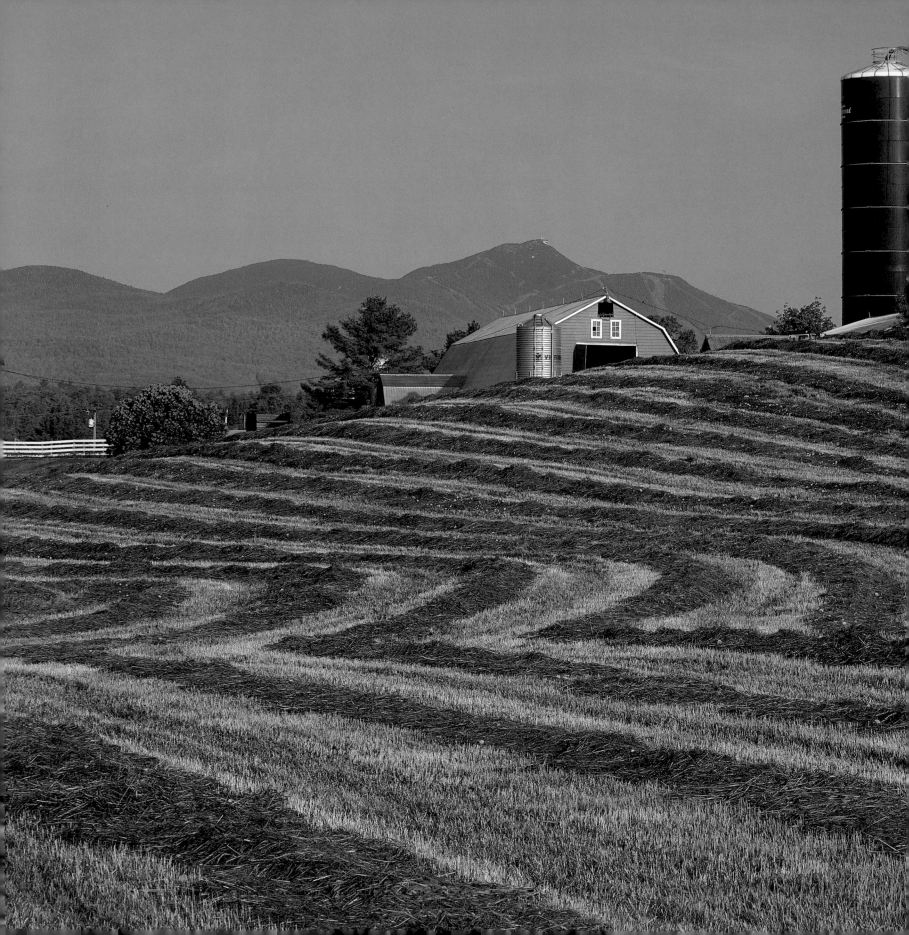

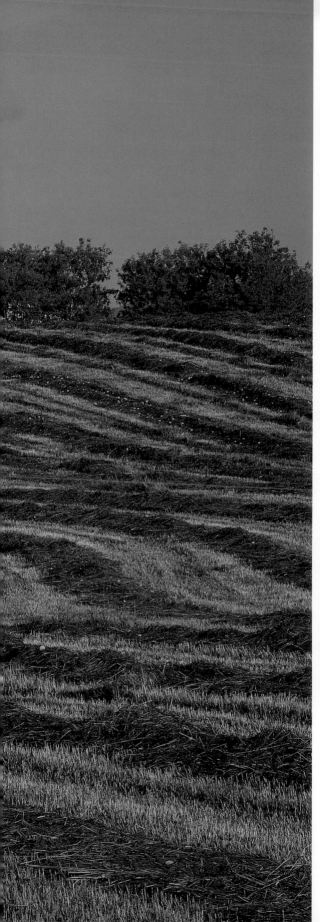

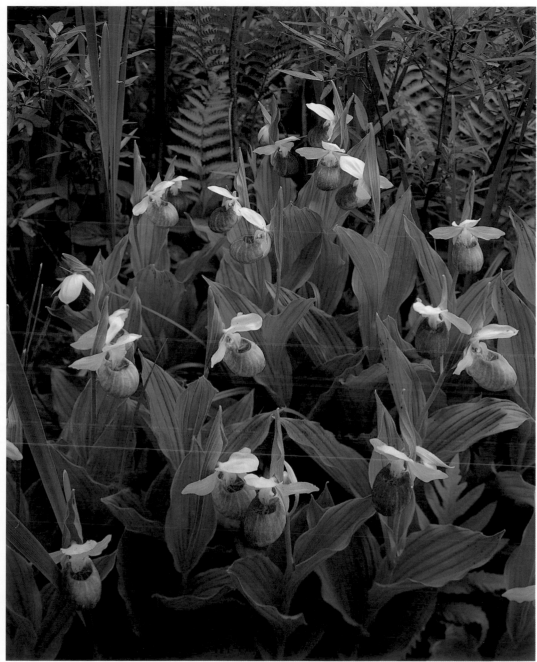

◄ Receiving more snow than any other area in the
East, Jay Peak, 2,153 feet, overlooks lilacs and windrows
of fresh-cut hay that embroider a farm in Newport, Vermont.
▲ Lady's slippers *(Cypripedium reginae)* brighten the Eshqua
Bog Natural Area in Hartland, Vermont. The area supports
a wide diversity of plant life, including such plants as
Labrador tea, cotton grass, and pitcher plants.

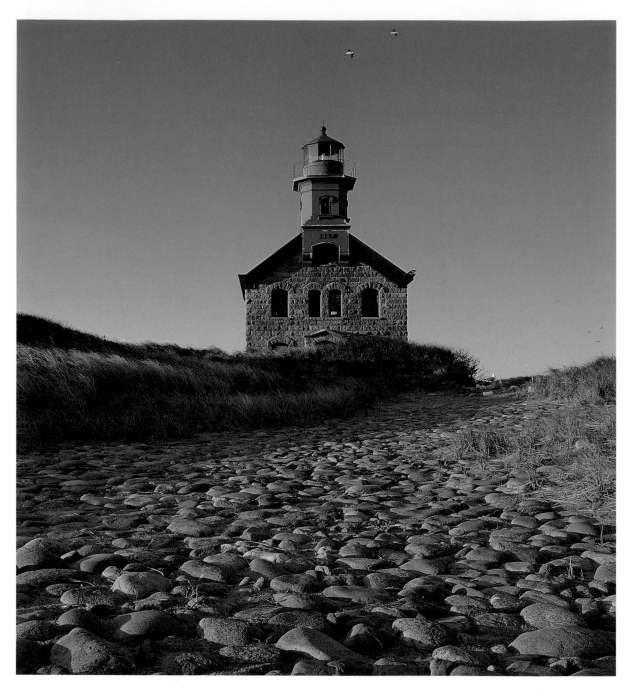

▲ Established in 1829, the North Light on Block Island,
Rhode Island, originally consisted of two lights on opposite ends
of a building. The present lighthouse was built in 1867. Intended to help
guide mariners into Block Island and Long Island Sounds, the light
also warns ships to stay away from dangerous Sandy Point. Between
1819 and 1838, fifty-nine vessels were wrecked in the area.

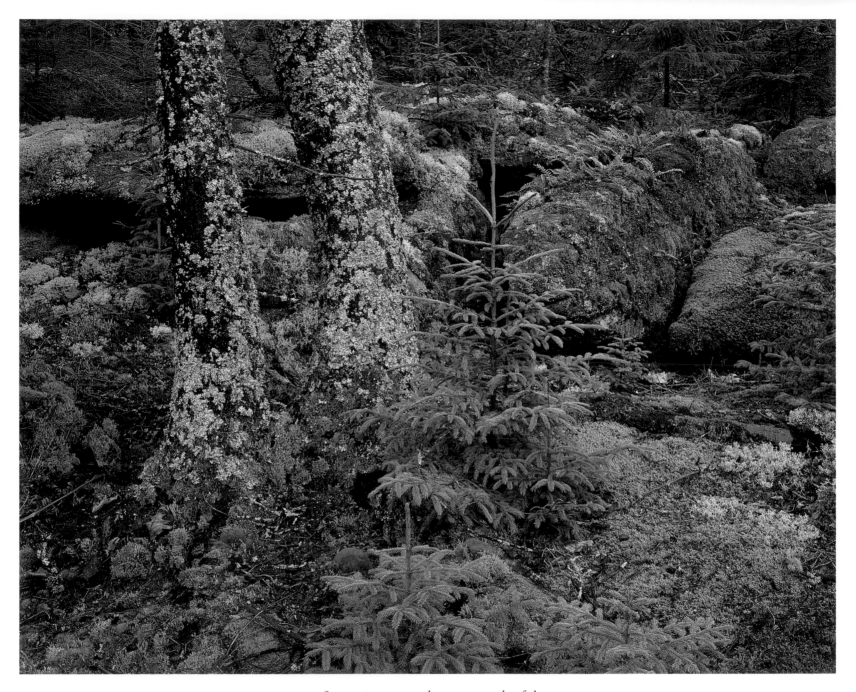

▲ Spruce trees are only one example of the
plant life found at the 250-acre Coastal Maine Botanical
Gardens in Boothbay, Maine. The botanic gardens emphasize
plants that naturally thrive in Maine, rather than exotics
brought in from other parts of the world.

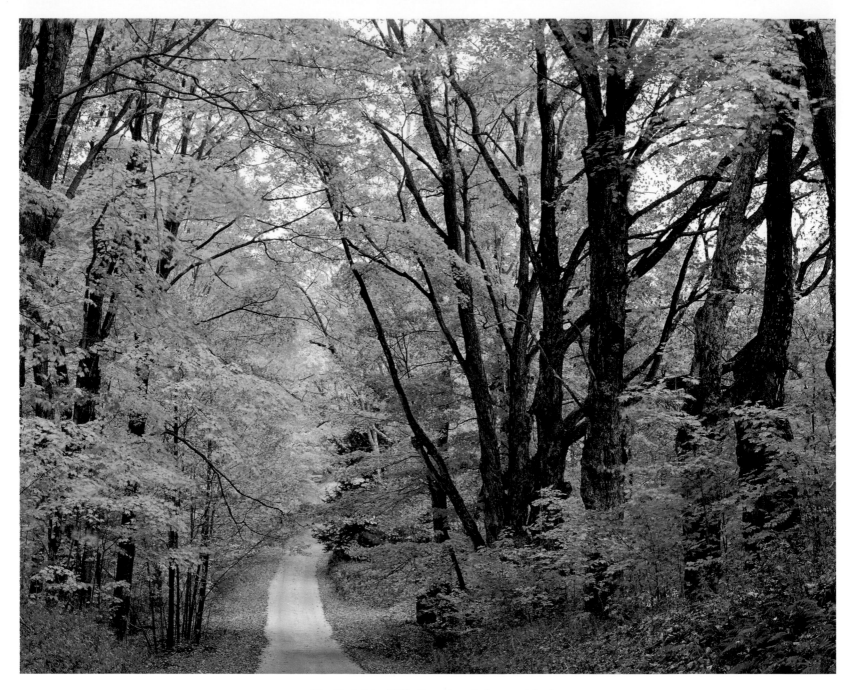

▲ The Berkshire Hills (locally called mountains)
in western Massachusetts are a branch of the Appalachian
Mountains. The highest elevation is Mount Greylock, at 3,491 feet.
► The Gates Farm Covered Bridge was built in 1897 on a farm
road in Cambridge Village, Vermont. It's sixty-foot
span allows passage over the Seymour River.

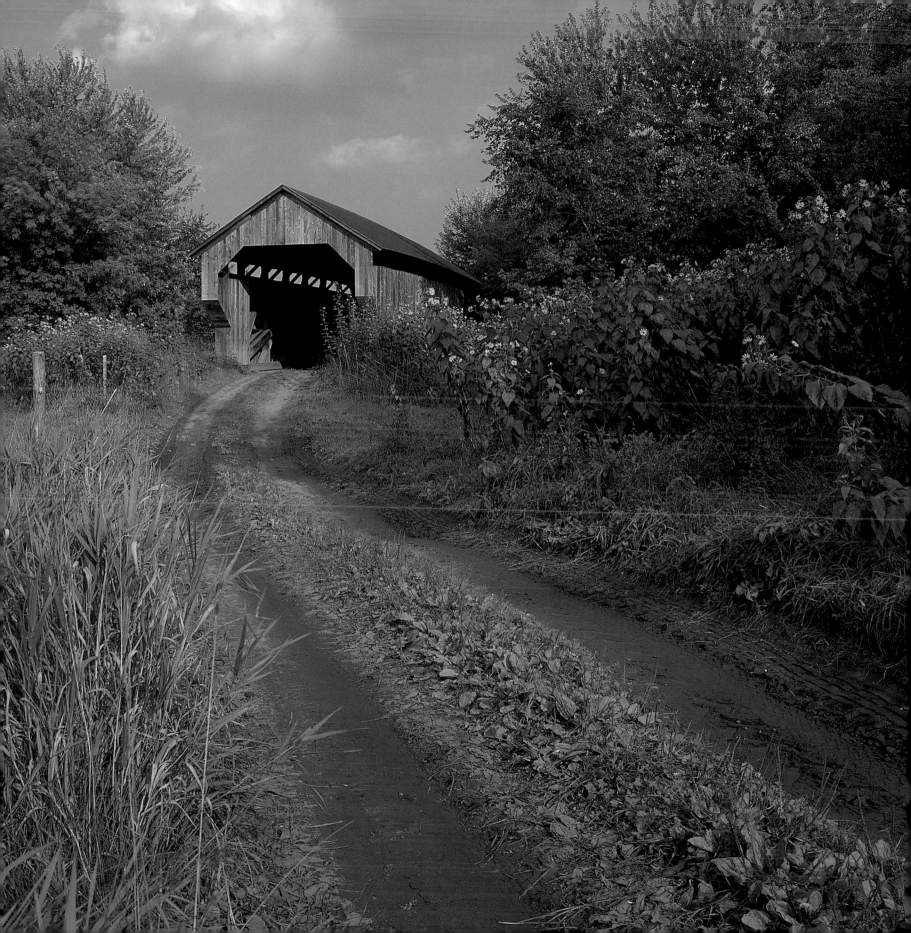

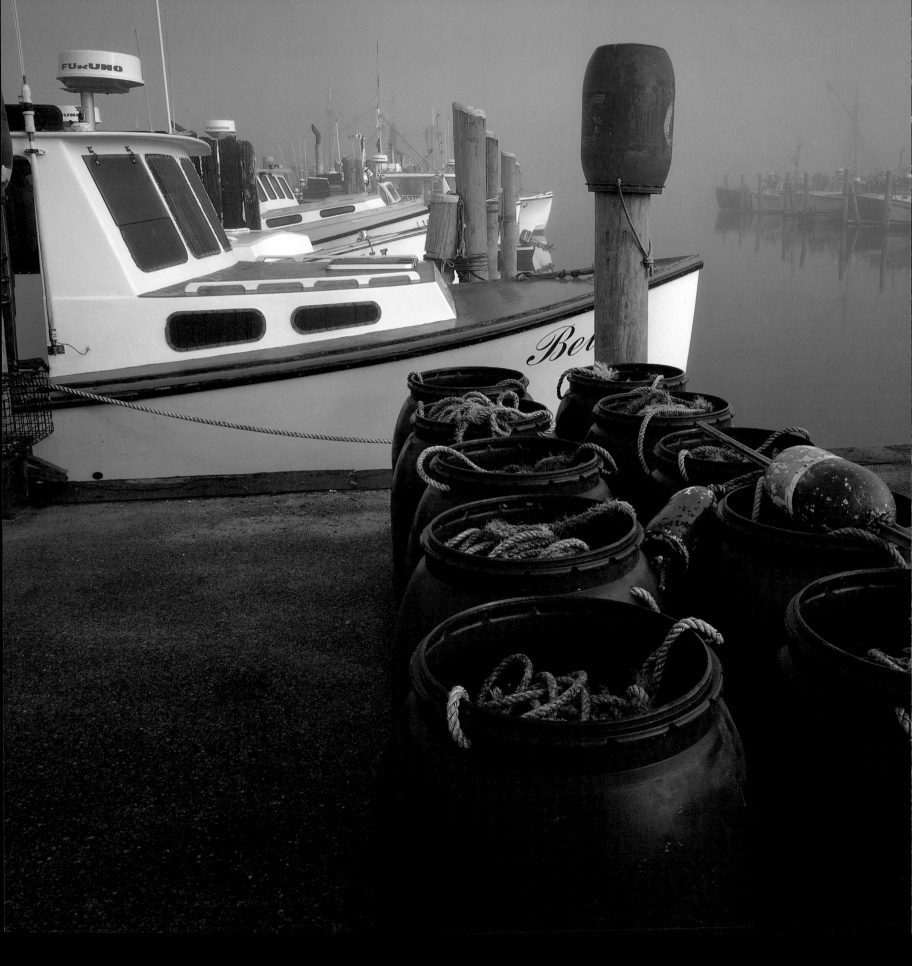

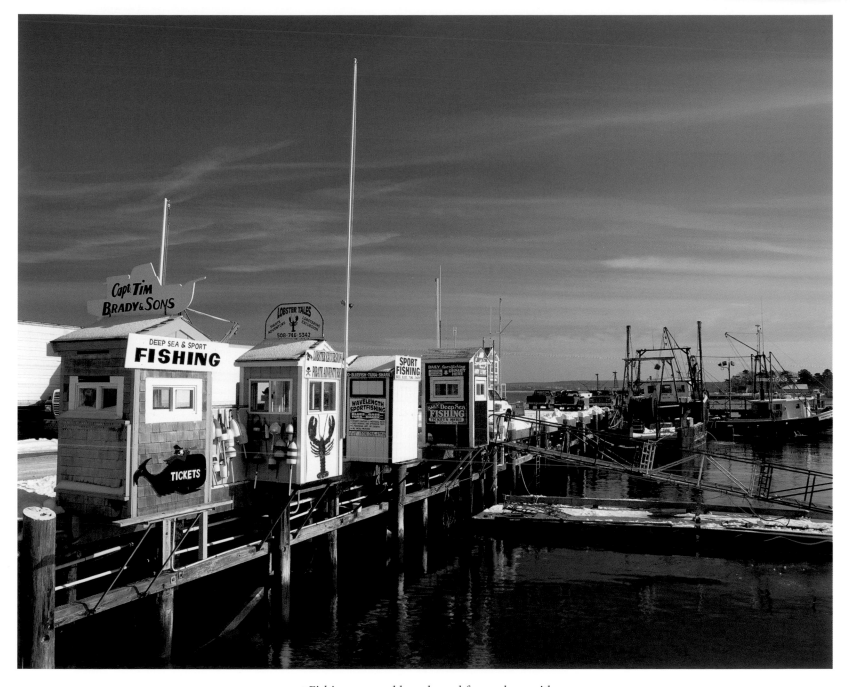

◄ Fishing gear, red barrels, and fog—along with
fishing boats at dock—show the marine character of the
Port of Galilee, located southwest of Narragansett, Rhode Island.
▲ The site of the landing of the *Mayflower* in 1620, Plymouth Harbor,
Massachusetts, continues to function as an active harbor.

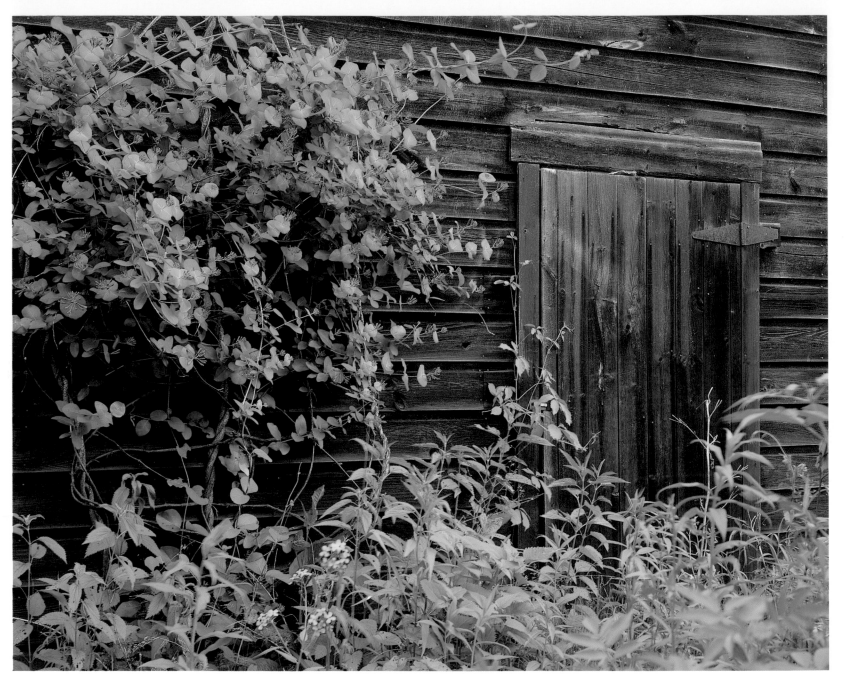

▲ An old icehouse door near Sharon,
Connecticut, is covered with honeysuckle vines. Ice,
stored in buildings such as this, was an important part of the
preservation of perishables before the advent of refrigeration.
► Built around 1637 for the Rev. John Smith and his wife and
thirteen children, Hoxie House, ensconced in Sandwich,
Massachusetts, is Cape Cod's oldest saltbox house.

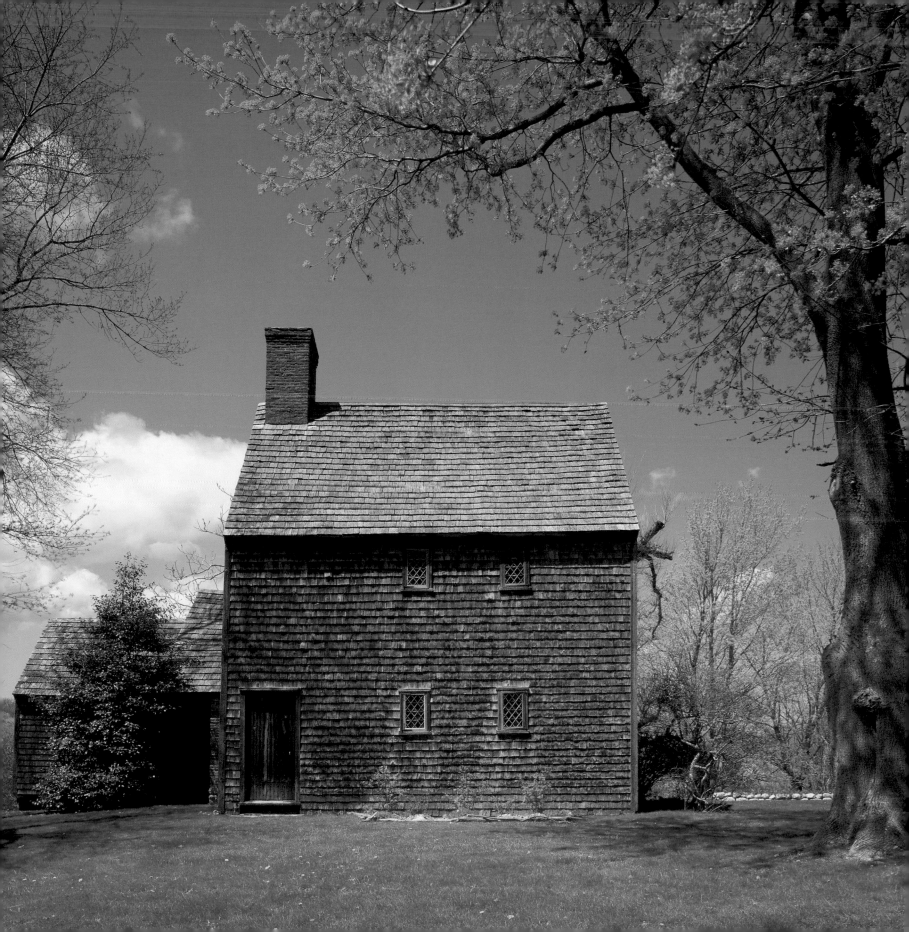

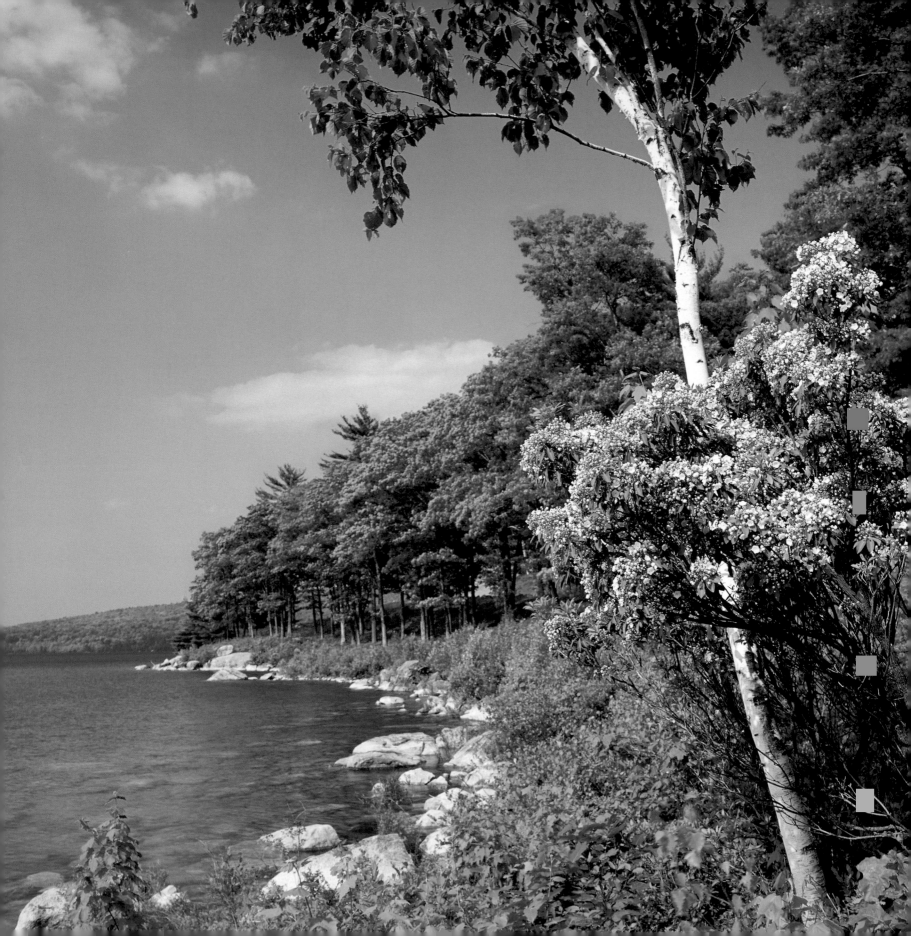

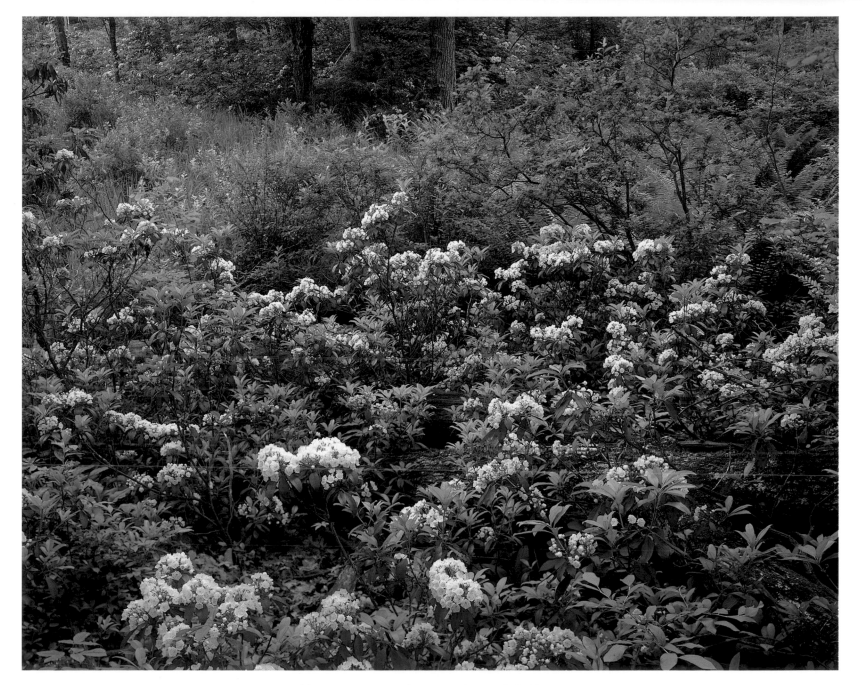

◄ Quabbin Reservoir supplies water for nearly half the people
of Massachusetts. Created in the 1930s by flooding four towns, the
reservoir, along with the land surrounding it, encompasses some 81,000 acres.
▲ Mountain laurel *(Kalmia latifolia)* dots the woodland area around
Sharon, Connecticut. A town of approximately 3,000,
Sharon is nestled in the Litchfield Hills.

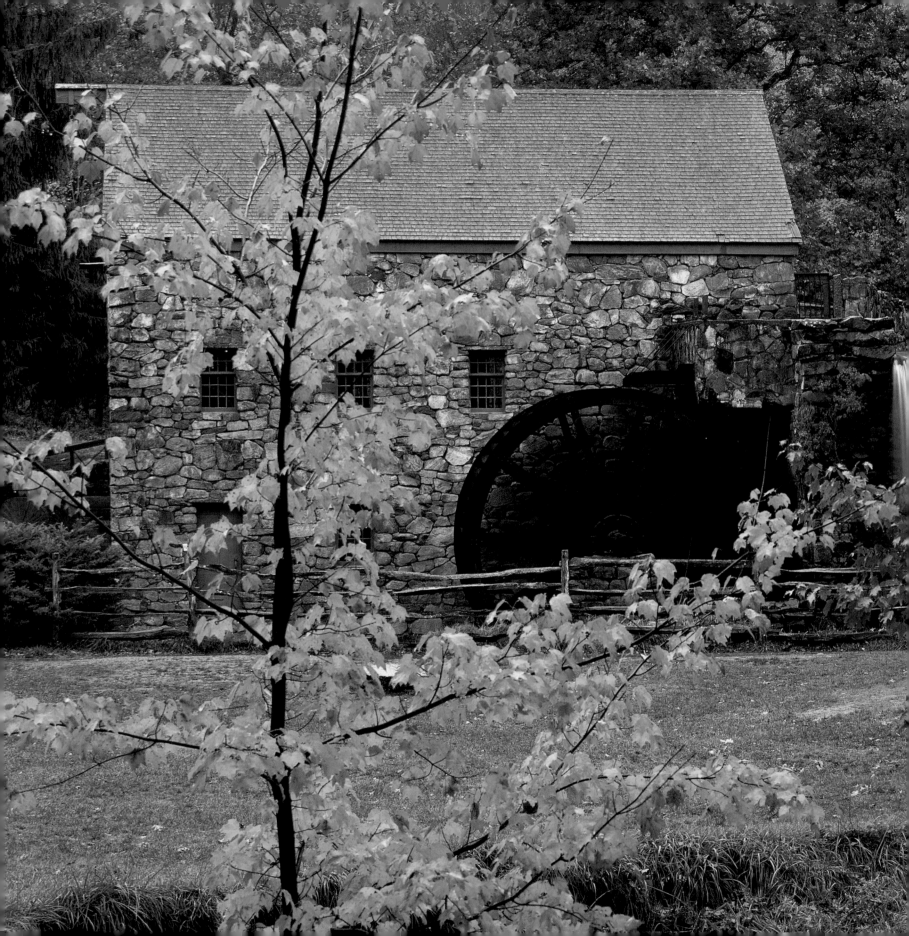

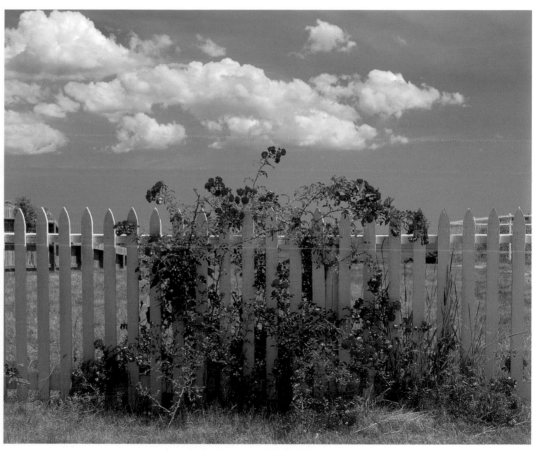

◄ The Wayside Inn Grist Mill, in Sudbury,
Massachusetts, was built in 1929 near the site of a mill
that was razed by Henry Ford a few years earlier. The present
mill, not a re-creation of the original one, was actually based on
architectural styles from further south, in Pennsylvania.
▲ Roses bloom on a picket fence in Martha's
Vineyard, Massachusetts.

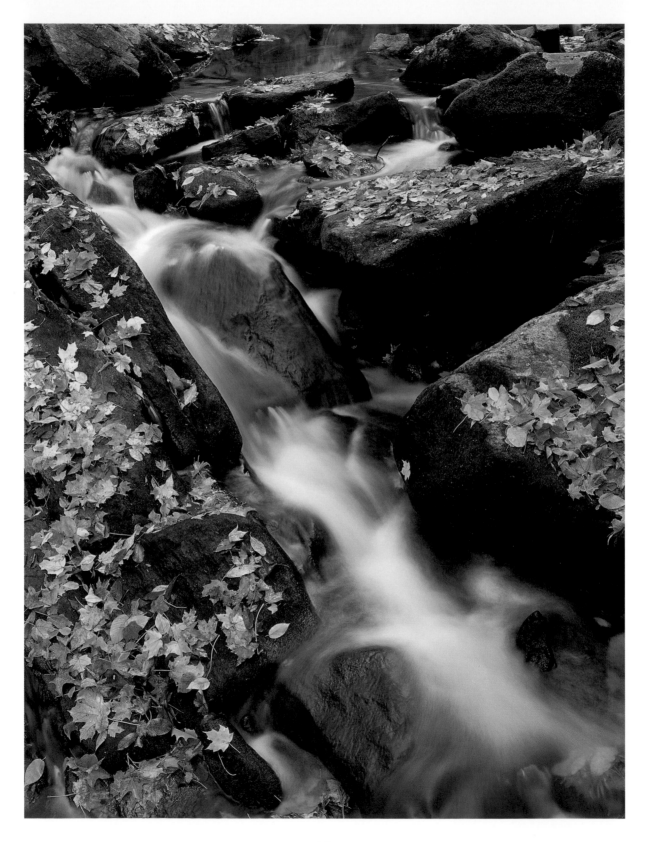

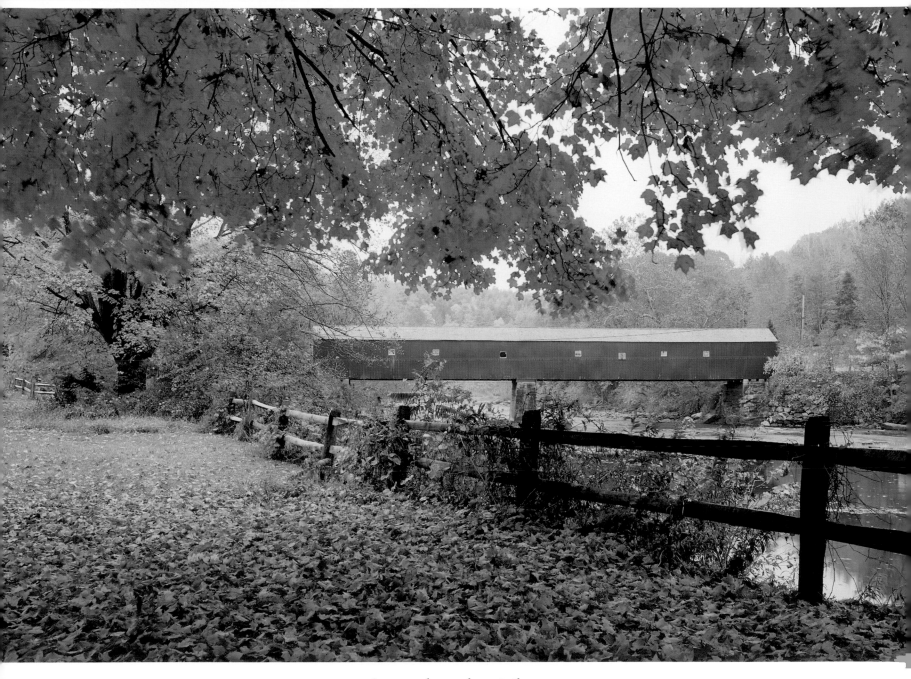

◄ Leaves and moss decorate the
banks of Mill Brook in Cornwall, Connecticut.
▲ The West Cornwall Covered Bridge, built in 1841, crosses
the Housatonic River with a span of 242 feet.

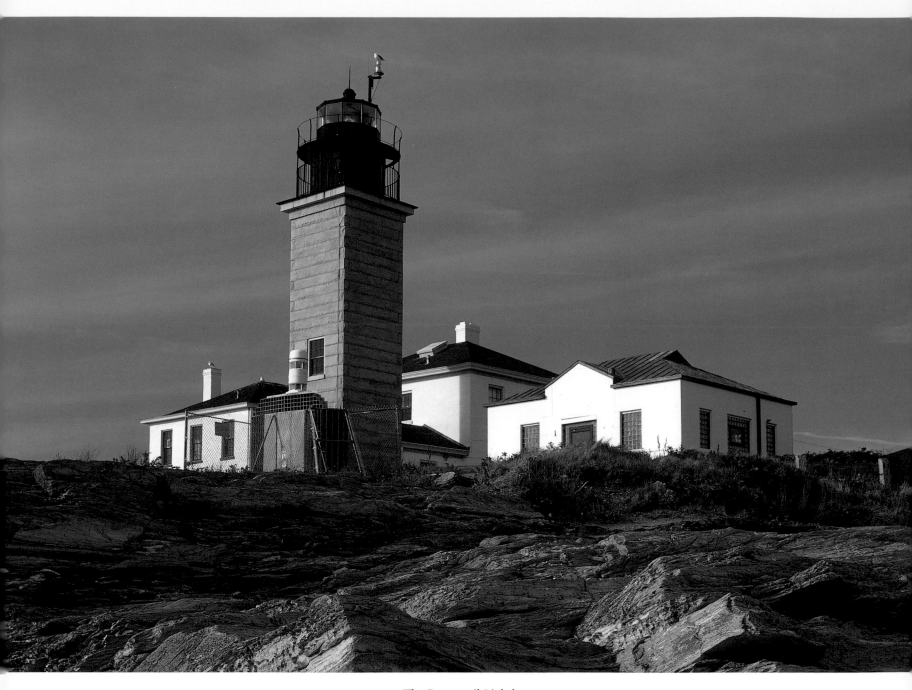

▲ The Beavertail Lighthouse
was established on Conanicut Island,
Narragansett Bay, near Jamestown, Rhode Island, in
1749. The present structure was built in 1856.

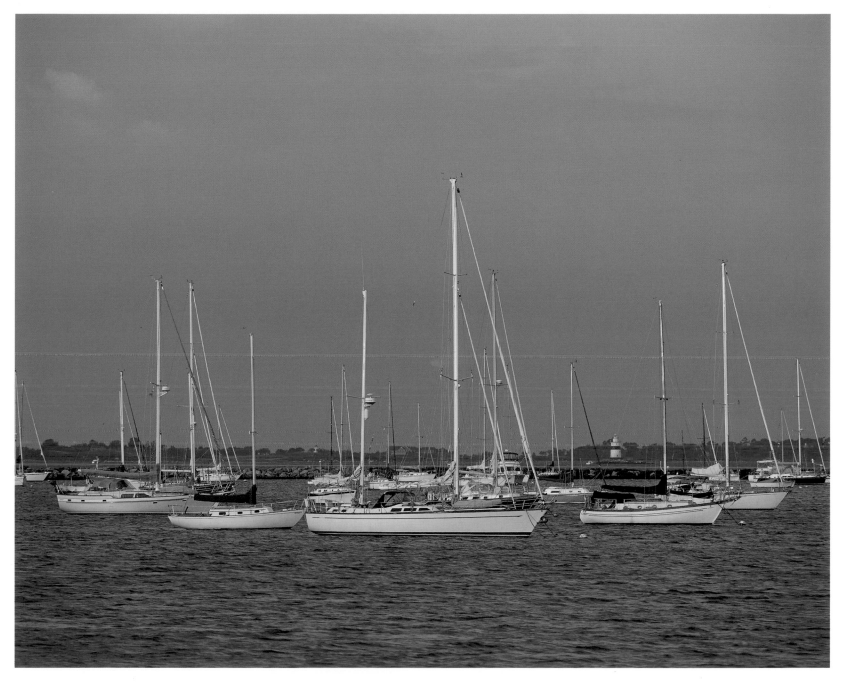

▲ Numerous seagoing vessels utilize
moorage at Stonington Harbor, Connecticut.
Stonington also offers historical attractions, including:
a lighthouse, founded in 1823 and now housing a museum; and
the Captain Palmer House, built in 1852 by two brothers,
Captains Nathaniel Brown Palmer and
Alexander Smith Palmer.

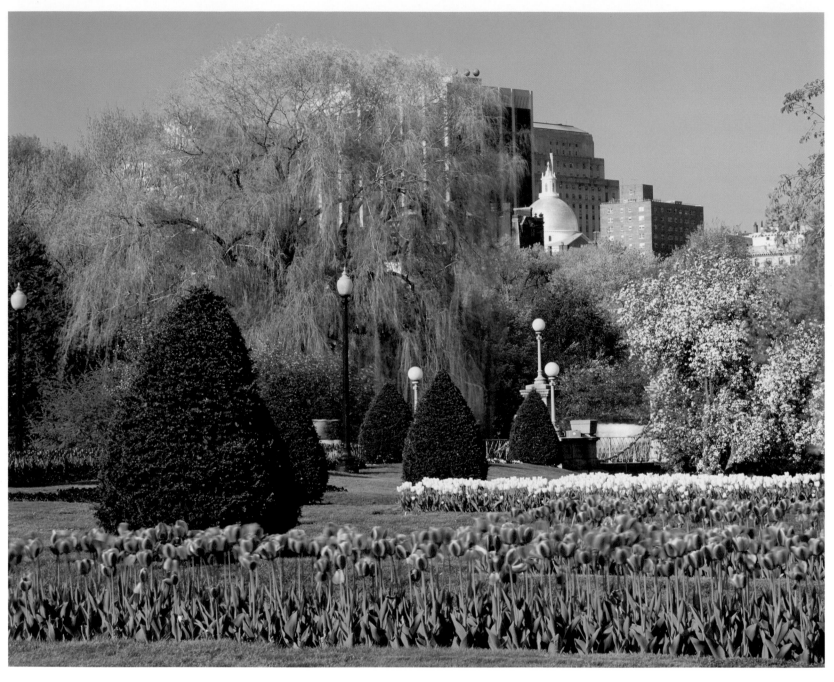

▲ The Boston Public Garden is a showplace of color
and design. The present Massachusetts State House, almost hidden
behind the lush plantings of the Garden, was completed in 1798, replacing the
1713 commonwealth building. It is the oldest structure on Beacon Hill.
The land it occupies once served as a cow pasture for the famous
signer of the Declaration of Independence John Hancock.

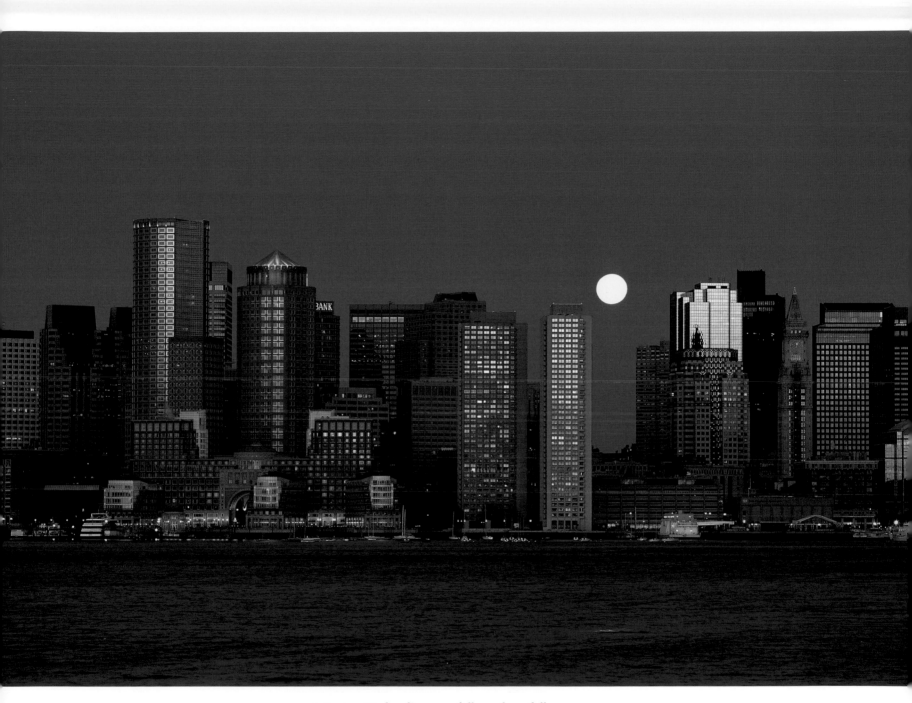

▲ Boston Harbor lies peacefully under a full moon.
In the early 1600s, a small group of Puritans began to settle
the area. Then in 1773, colonists, unhappy with British taxes, slipped
aboard an English ship and threw the tea cargo overboard in
protest. Just two years after the so-called Boston Tea Party,
the Revolutionary War broke out in earnest.

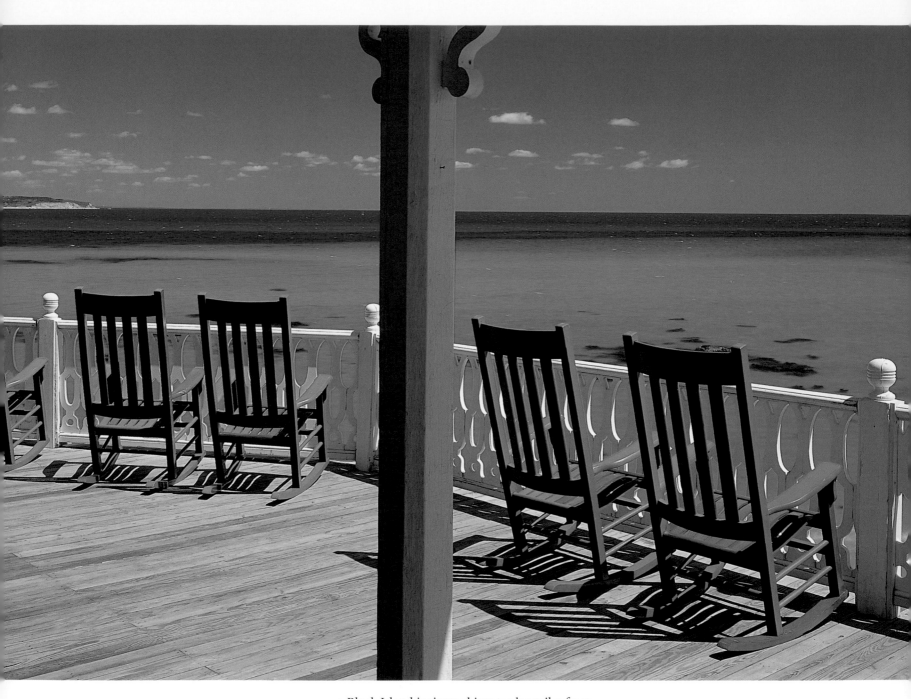

▲ Block Island is situated just twelve miles from
the Rhode Island mainland. Its seventeen miles of pristine
beaches, lighthouses, and awe-inspiring bluffs make it a favorite
getaway destination. In addition to its shoreline attractions, Block
Island's twenty-five square miles include hundreds of freshwater
ponds and more than 2,000 miles of stone walls.

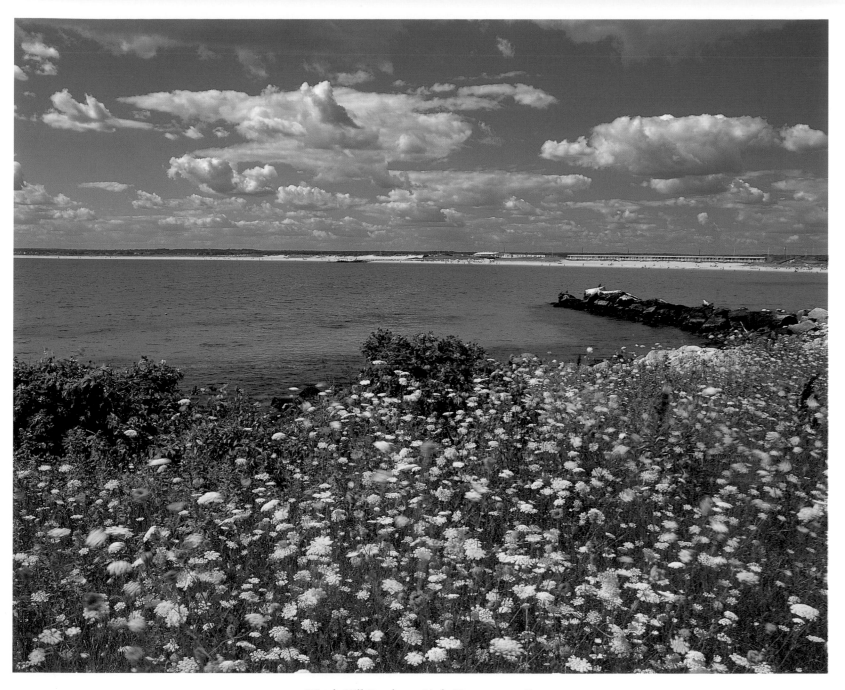

▲ Watch Hill Beach, on Little Narragansett Bay,
Rhode Island, is carpeted with Queen Anne's lace in summer.
The colonists used the area as a lookout point during the French
and Revolutionary Wars; hence the name "Watch Hill."

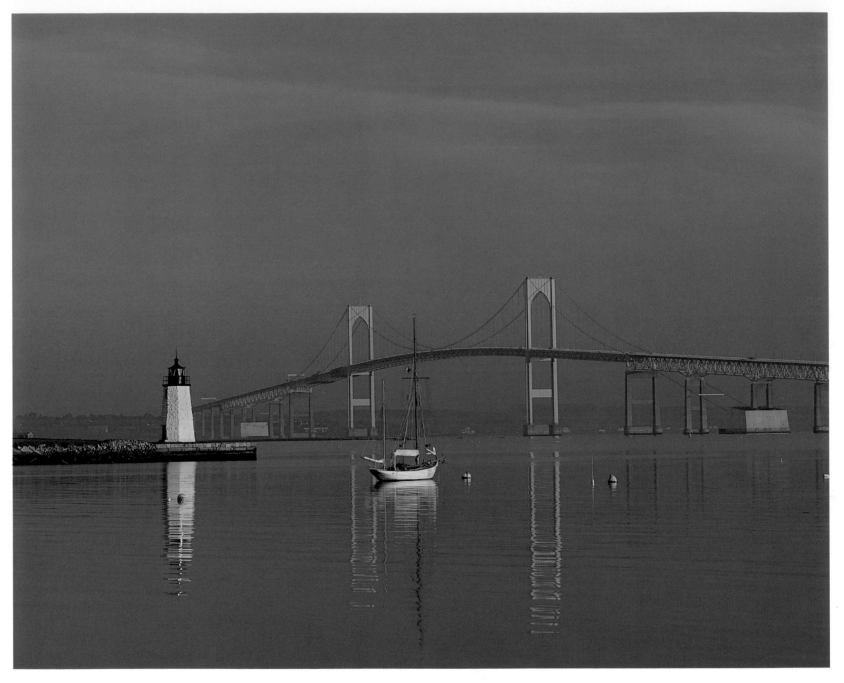

▲ The thirty-five-foot-high Goat Island Light is situated
in the entrance to Newport Harbor, Rhode Island. Established in
1824, the light was automated in 1923 and still warns boats of danger nearby.
► A small rivulet heads toward the Sandy Stream in Maine's 202,064-acre Baxter
State Park. Former Gov. Percival P. Baxter donated the park's original acreage to the state.
►► Lilacs decorate a weathered barn in Peacham, Vermont. Settled in 1776, the town might
have been named for Polly Peacham, a character in John Gay's *The Beggar's Opera*.

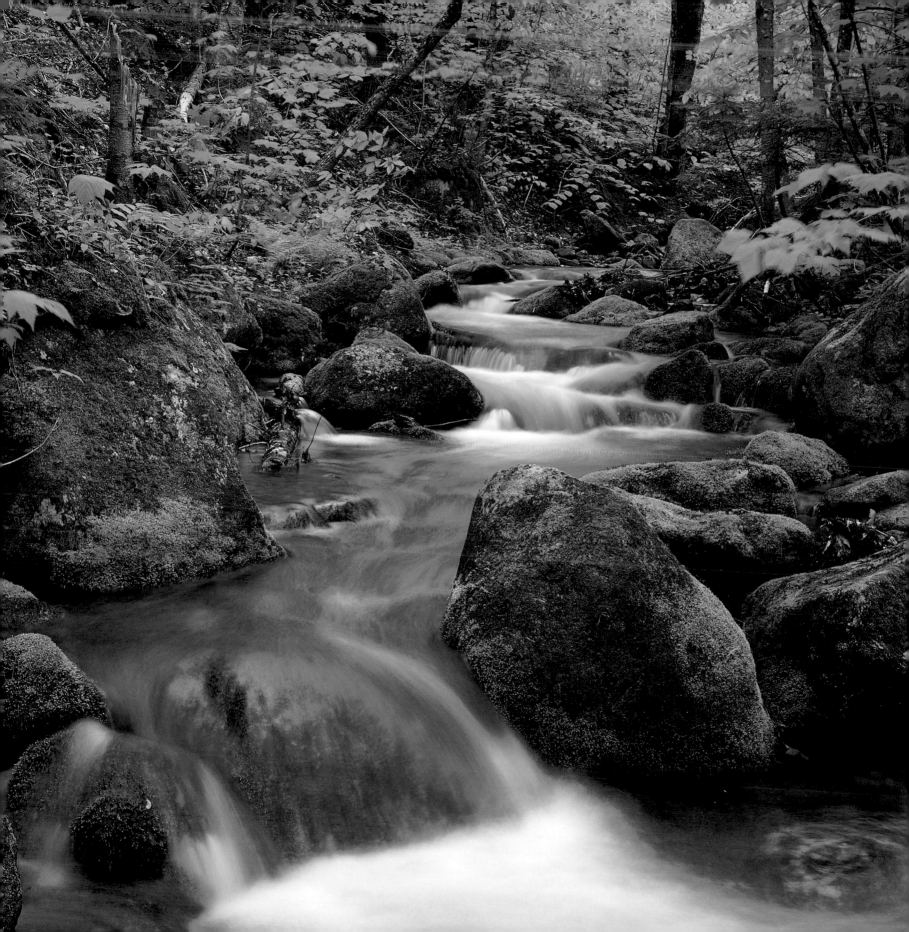

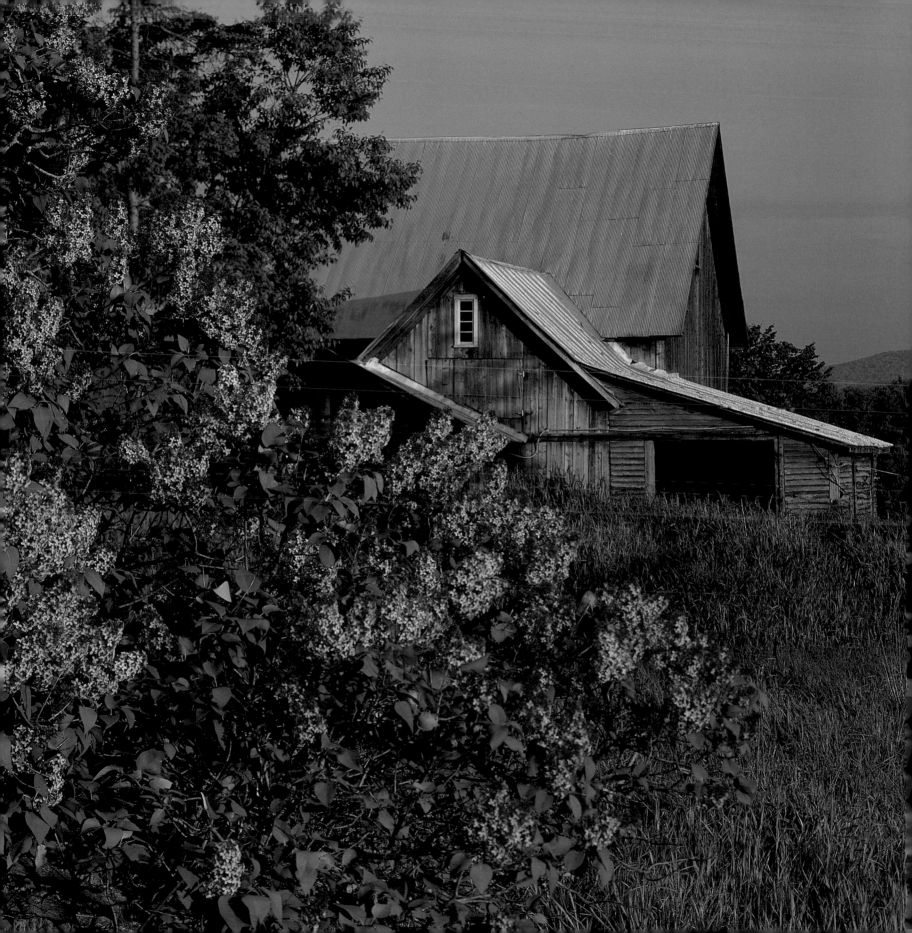

▲ Throughout New England, such brilliant
trees as this one in Bristol, New Hampshire, show
why leaf peeping is such a popular activity each autumn.
▶ Monument Mountain, near Great Barrington, Massachusetts,
rises to 1,735 feet. Several miles of hiking trails wind through a forest
of white pine and oaks—interspersed with chestnut saplings,
tulip trees, maples, and mountain laurel—to reach the top.

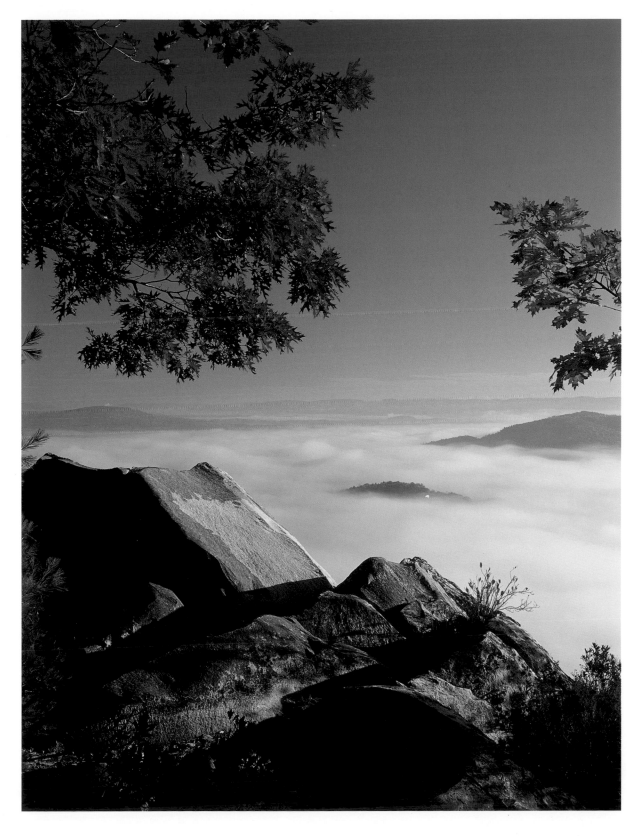

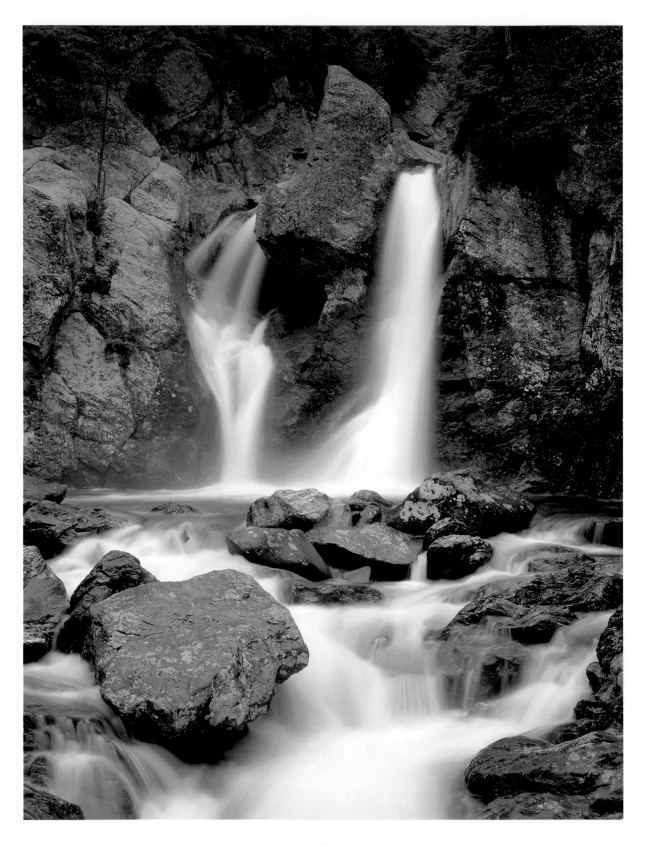

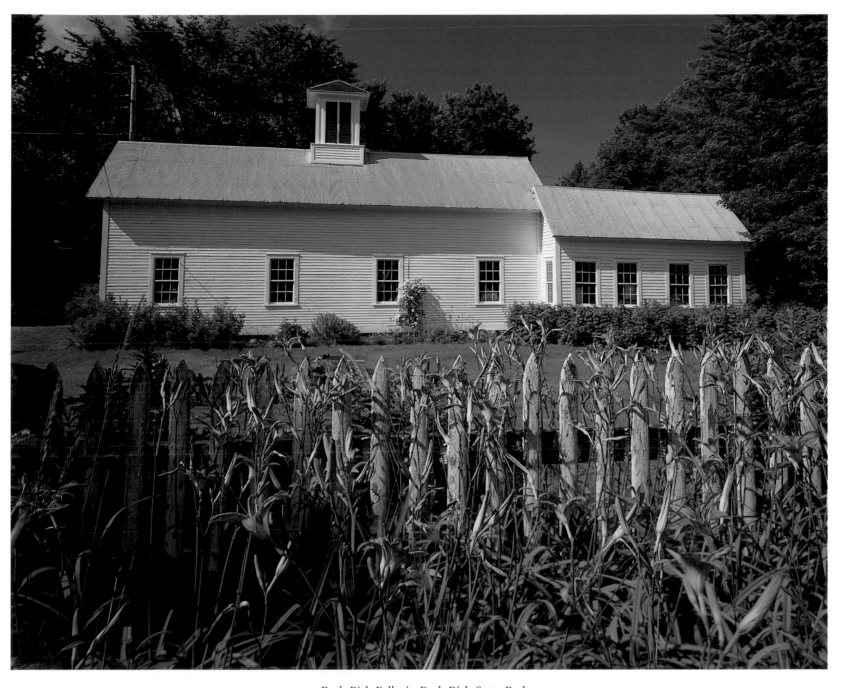

◄ Bash Bish Falls, in Bash Bish State Park,
Massachusetts, is situated within the Mount Washington State
Forest. Most visitors to the state park have one goal in mind—a glimpse
of the twin falls that drop in a dramatic, eighty-foot V over steep boulders.
▲ Daylilies grace a picket fence in Newfane, Vermont. Founded in 1774 on
a 1,600-foot hill that proved to be inaccessible in winter, the town
was moved to its present location on a valley floor in 1825.

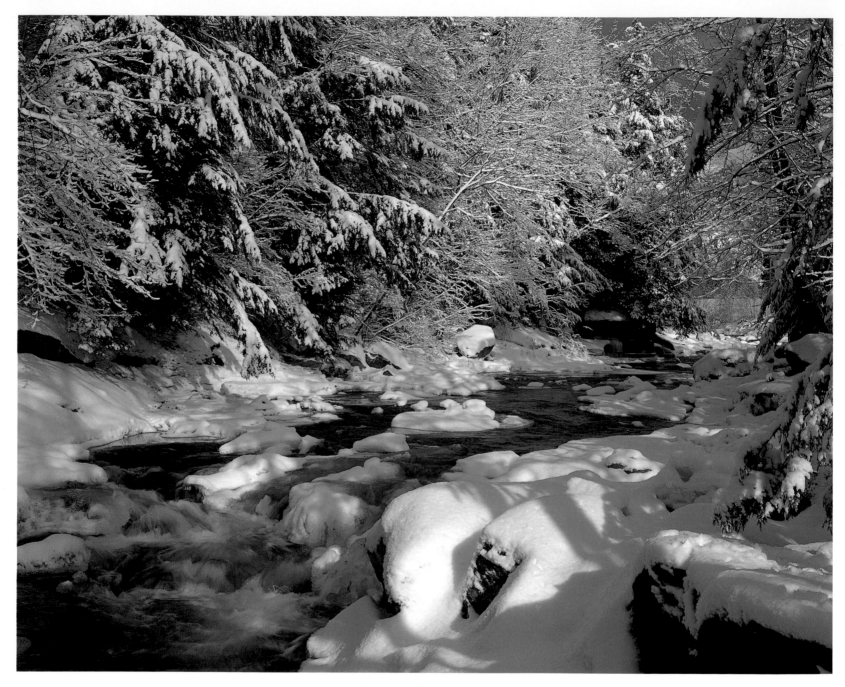

▲ Fresh snow pillows the banks of
the Baker River, New Hampshire. The river is
shallow enough that, in summer, one can wade the river—
or raft it, as long as the raft is not too heavily loaded.
▶ At 4,180 feet, Old Speck Mountain is the
third-highest peak in Maine.

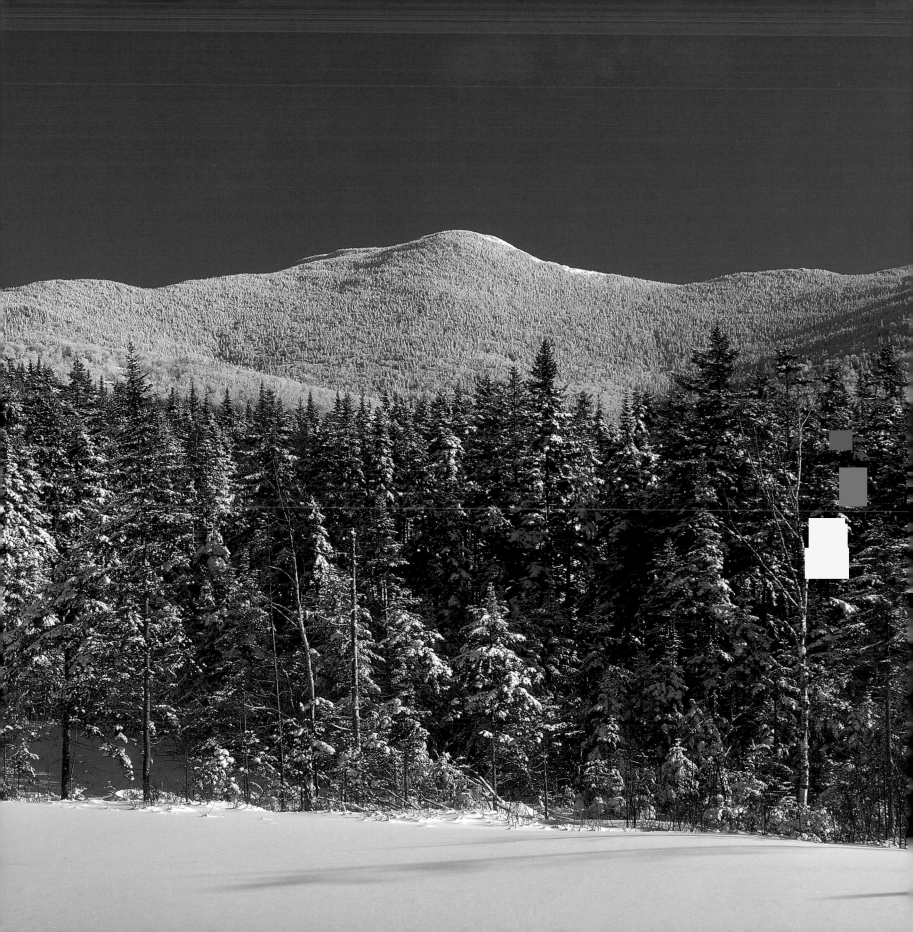

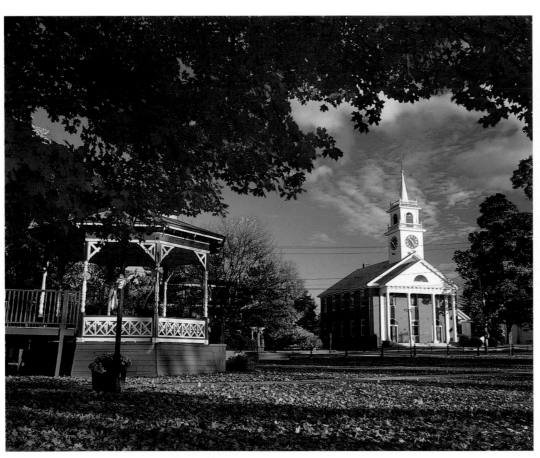

▲ A gazebo adorns the village green of Townsend, Massachusetts. The red brick portion of the present Congregational Church in the background was built near the town common in 1830, but the congregation had first worshiped in 1734 in a different sanctuary.

► In 1728, the town of Jamestown, Rhode Island, built a windmill for grinding corn. Since there was no source of running water to turn a waterwheel, the sea breeze was used for power.

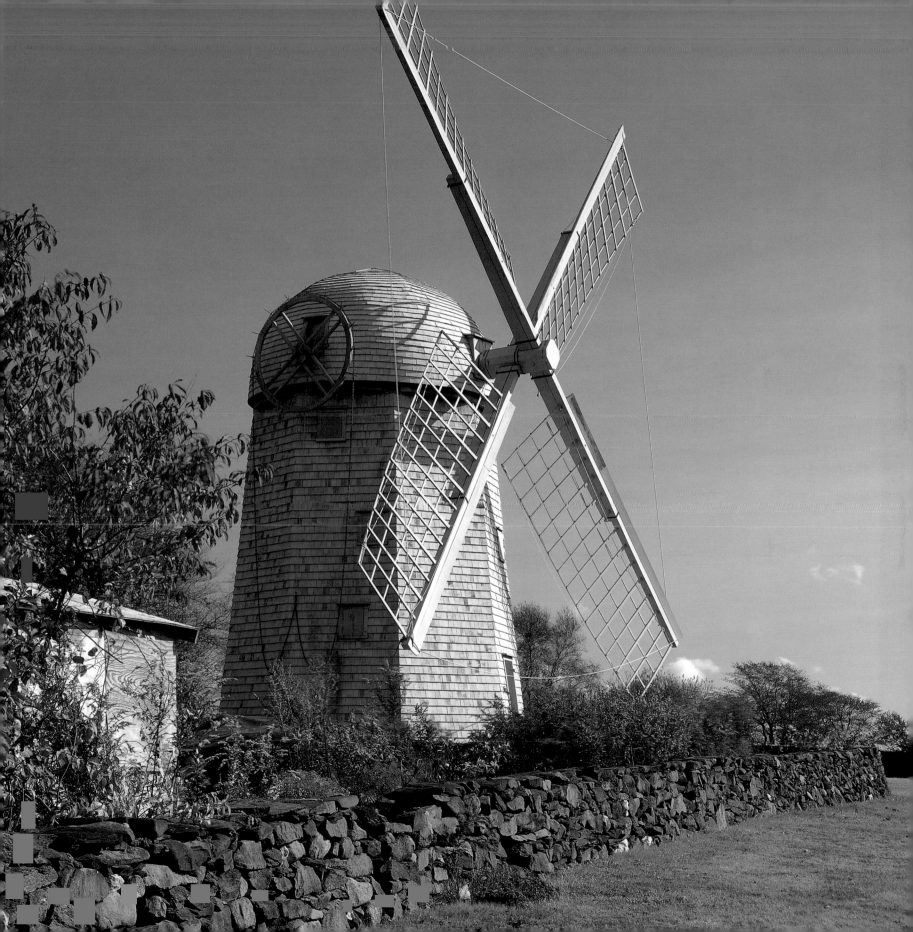

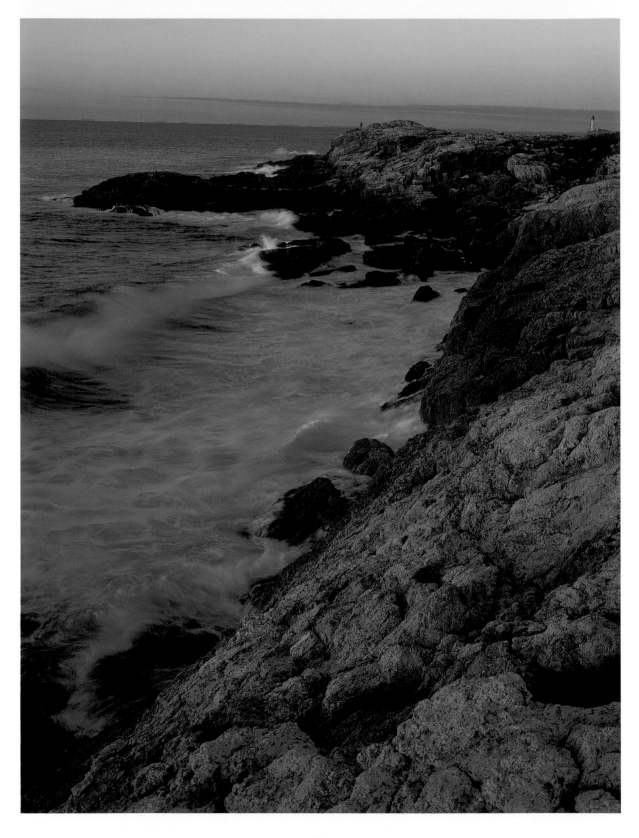

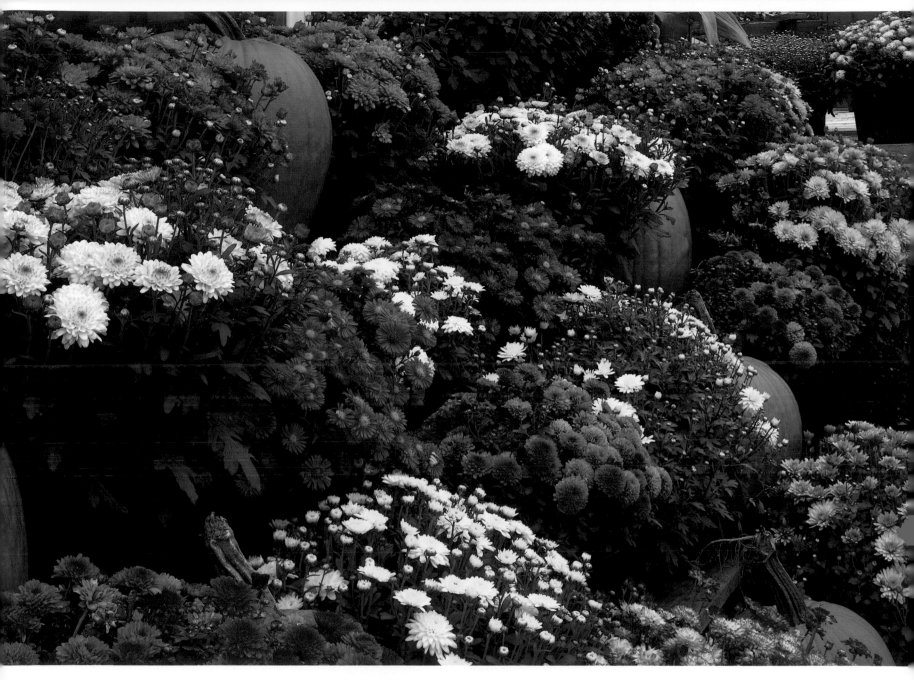

◀ Located nine miles from Portsmouth,
New Hampshire, a cluster of eighteen islands and
rocks makes up the Isles of Shoals. The first lighthouse
in the Isles of Shoals was established on White Island in 1821.
▲ Chrysanthemums and pumpkins have been arranged
in a colorful display on a farmstead near
Littleton, New Hampshire.

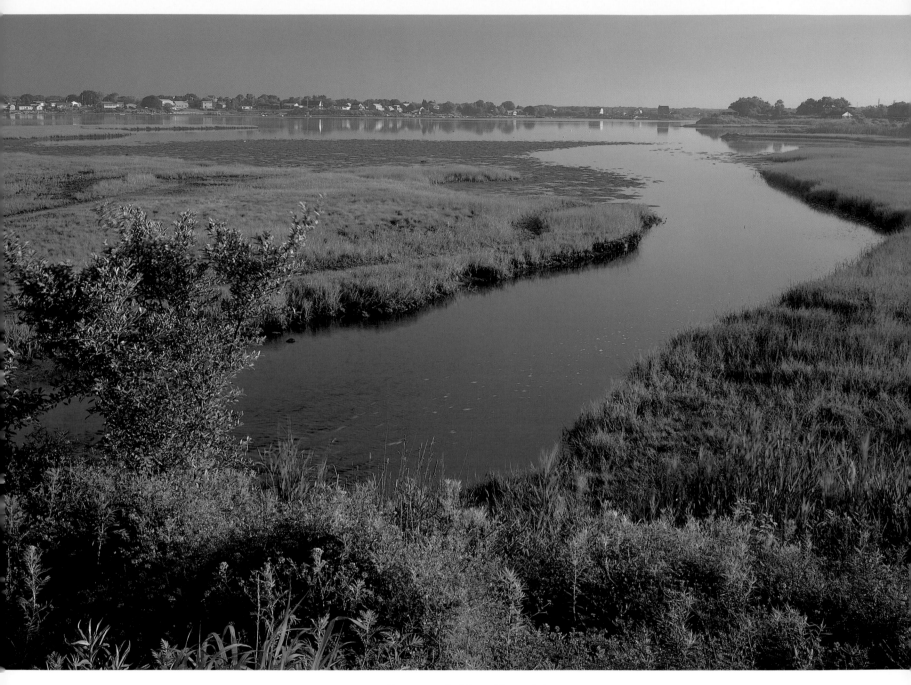

▲ Crown vetch *(Coronilla varia)*
thrives at Point Judith Pond, Rhode Island, a
midsalinity estuary used by mussels for spawning—
and people for fishing. Point Judith Pond also offers boaters
opportunities to explore among its numerous
islands and along its shoreline.

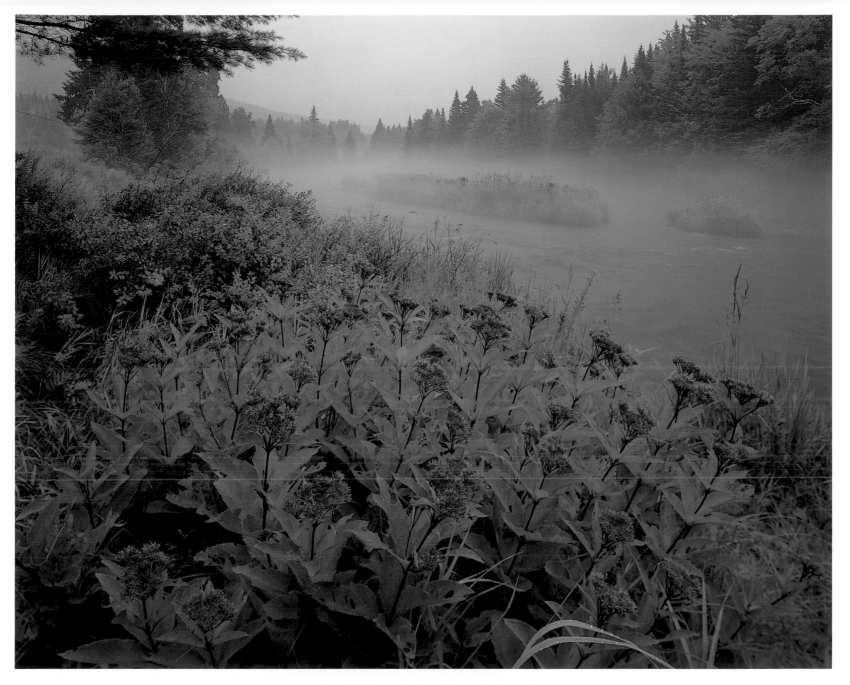

▲ Near Pittsburg in New Hampshire's north
country, joe-pye weed *(Eupatorium fistulosum)* enlivens
a foggy Connecticut River. Alternative medicine uses all the
various parts of the plant to treat a number of ailments.

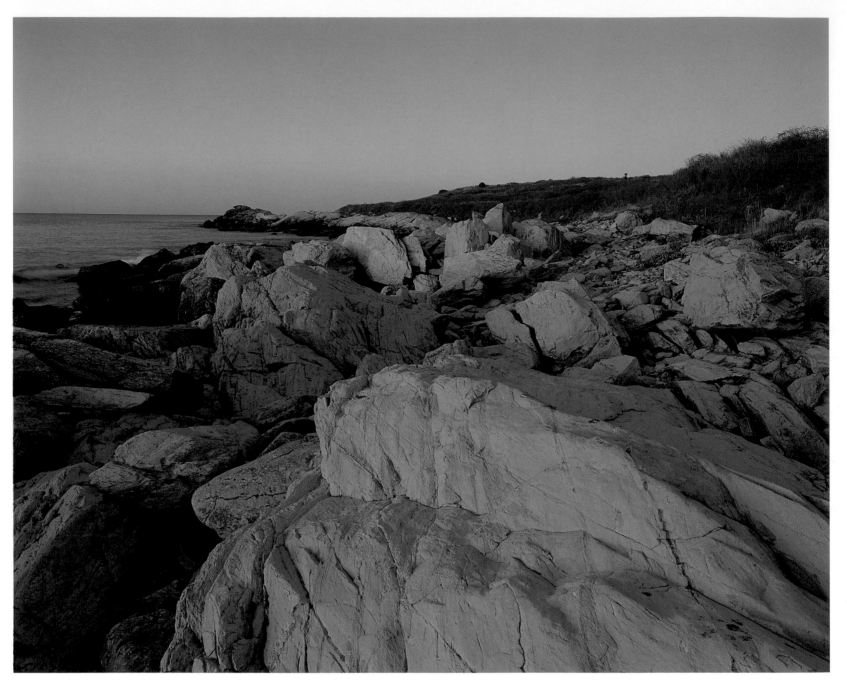

▲ The 242-acre Sachuest Point National Wildlife Refuge, situated on a peninsula
between the Sakonnet River and Rhode Island Sound, supports more than 200 bird species.
► Topped by beach grass, sand dunes at Hampton Beach, New Hampshire, are designed by wind.
Activities at the beach include fishing, whale watching, water slides, kayaking, and boating.
►► A lichen-covered ledge at the forty-one-acre Two Lights State Park, Maine, sets
off the Cape Elizabeth Light. Built in 1828 as one of two lights, the light is
visible seventeen miles out at sea. Its twin is now a private home.

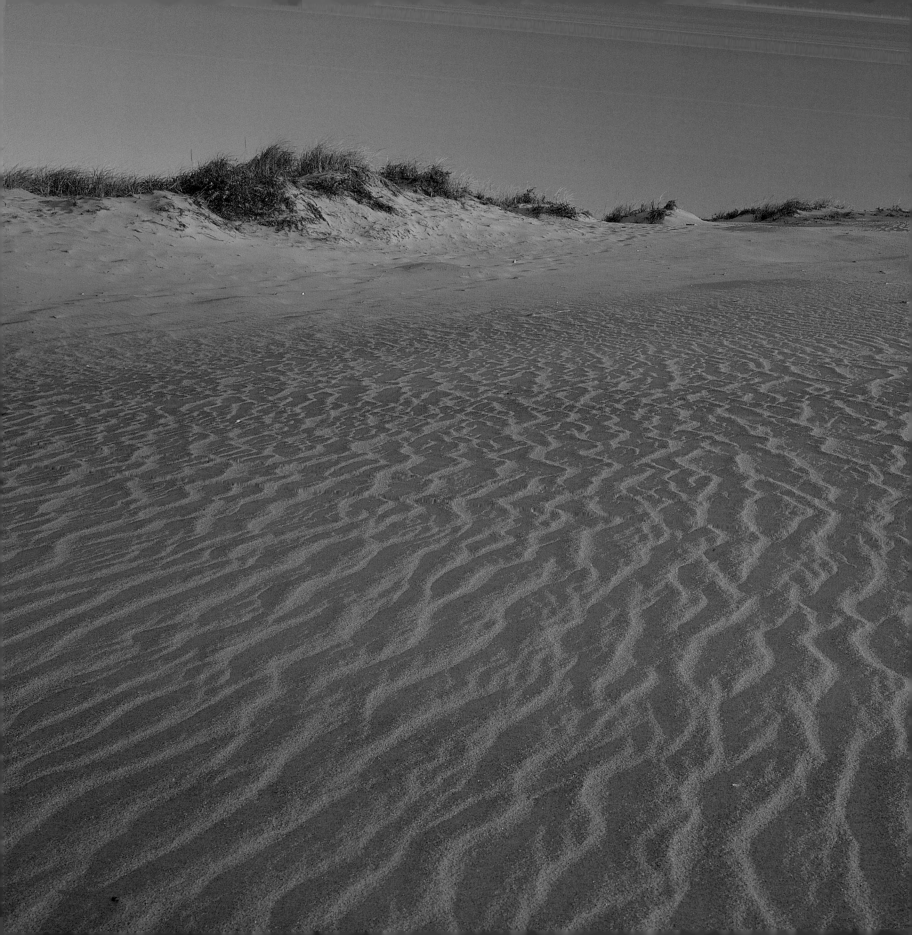

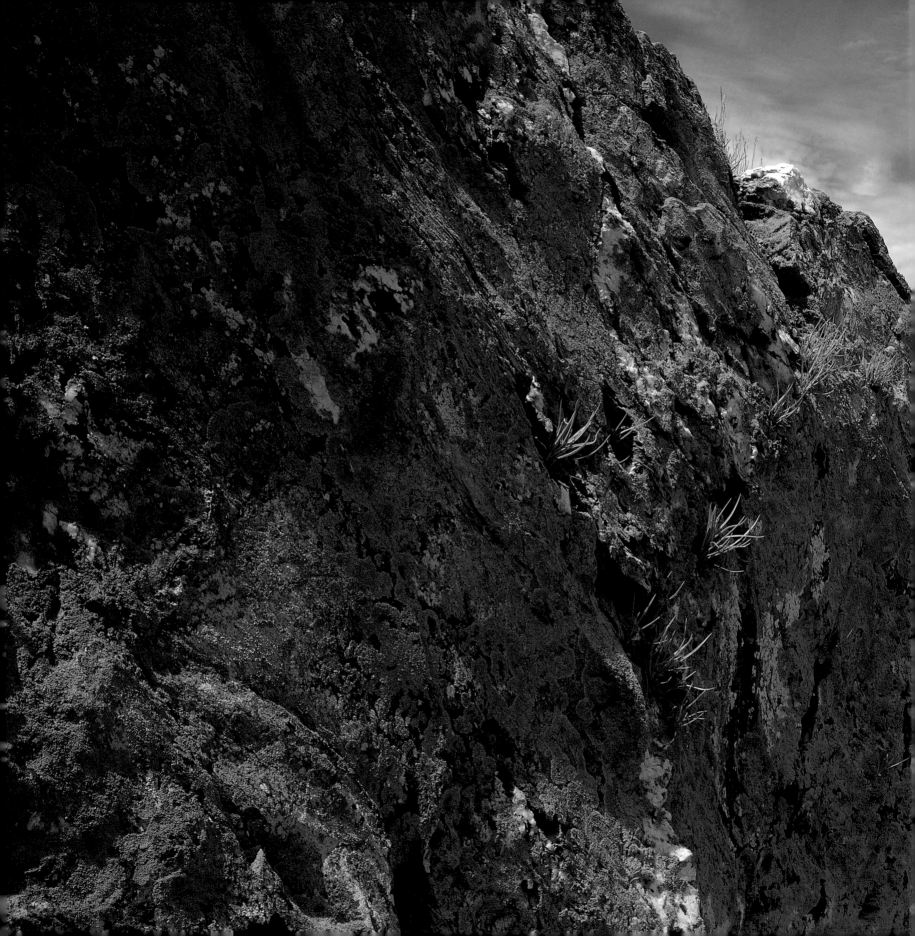

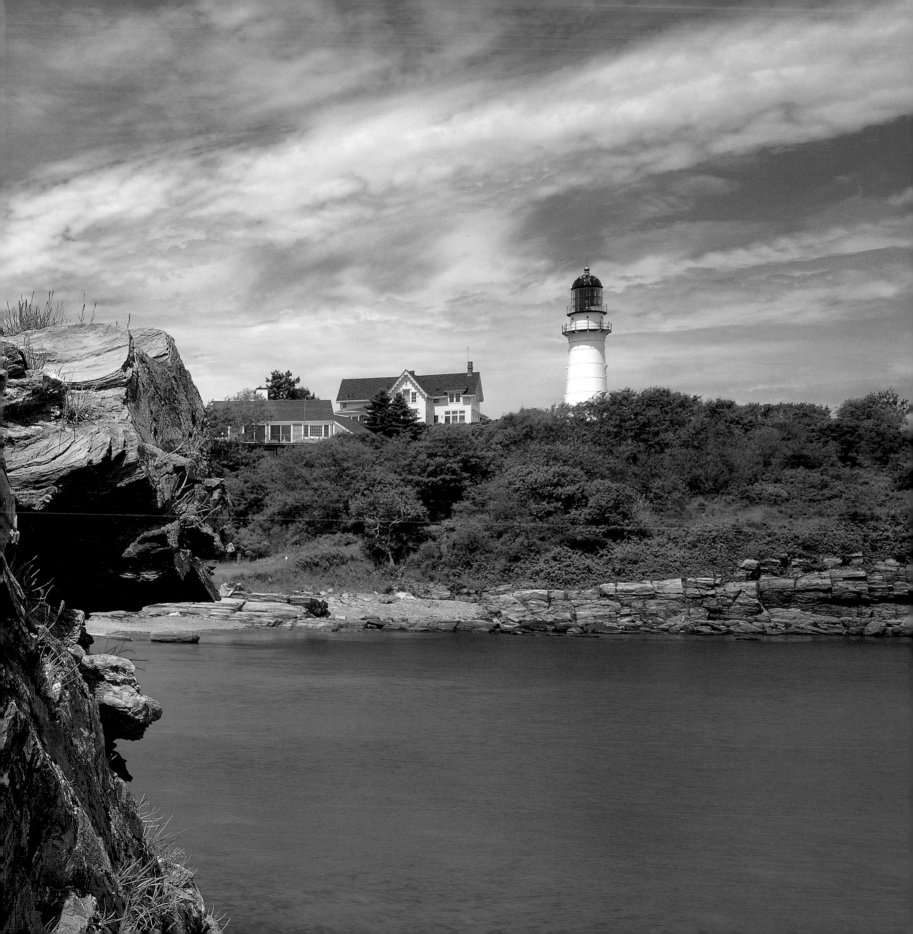

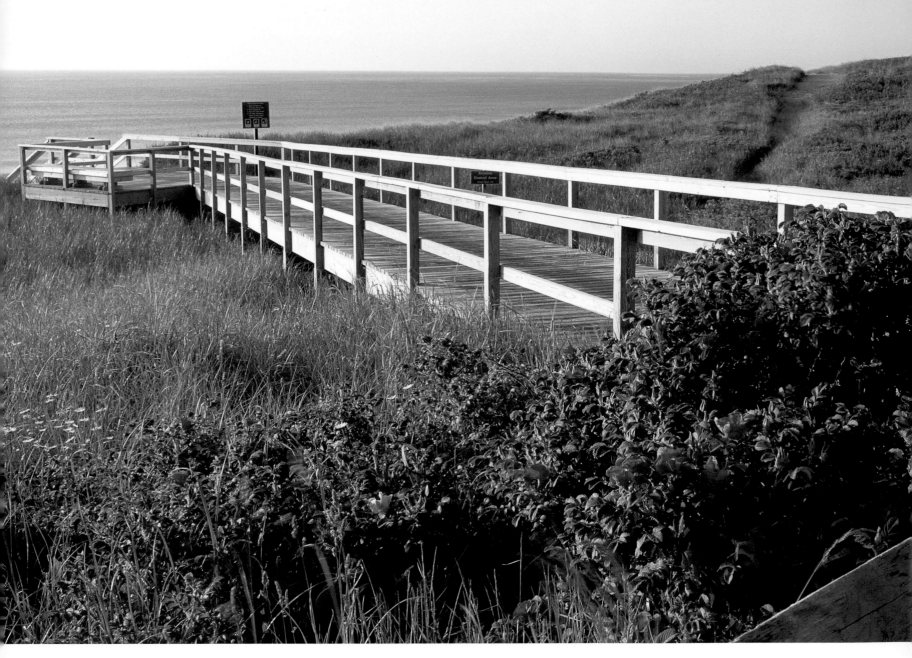

▲ A boardwalk leads to Nauset
Light Beach, on Cape Cod National Seashore.
The national seashore protects 43,604 acres of shoreline and
upland landscape, lighthouses, historic structures,
beaches, trails, and picnic areas.

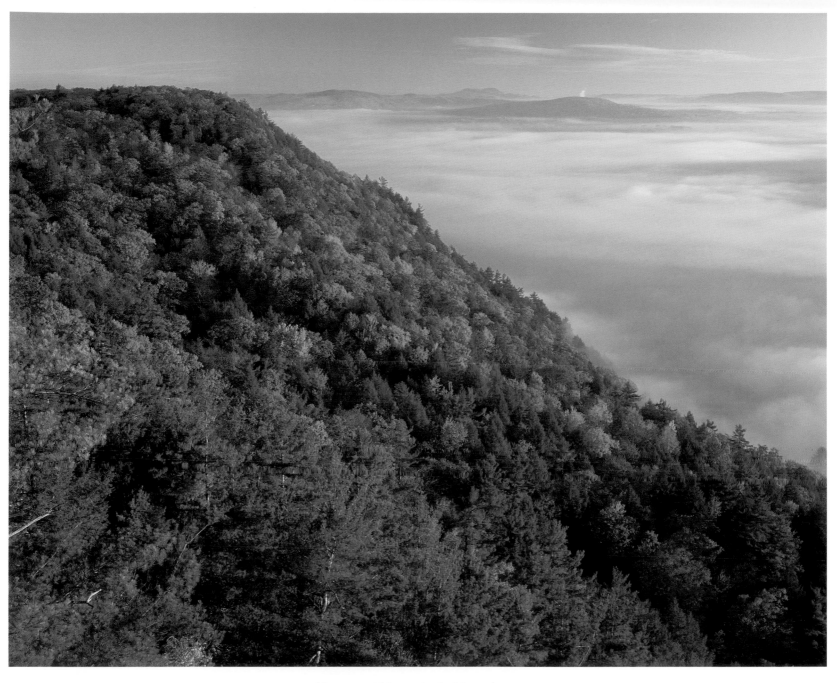

▲ Monument Mountain, in Massachusetts,
overlooks the Housatonic River Valley. The Housatonic River
flows 149 miles from its sources in western Massachusetts before
it empties into the Long Island Sound at Milford Point. The
property is protected by the Trustees of Reservations, a
conservation group that dates back to the 1890s.

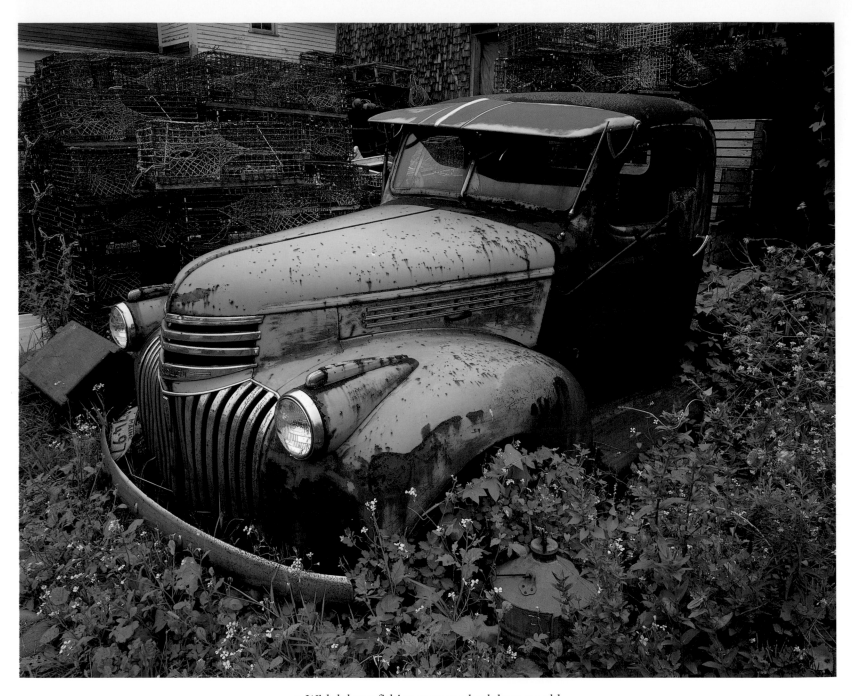

▲ With lobster fishing gear as a backdrop, an old
Chevy truck—wildflowers anchoring it to the ground—
is slowly becoming part of the landscape of Cape Porpoise, Maine.
► Mystic Seaport, Connecticut, is home to a copy of the lighthouse at
Brant Point in Nantucket, Massachusetts. The first Brant Point Lighthouse,
the second operative lighthouse in New England, was built in 1746.

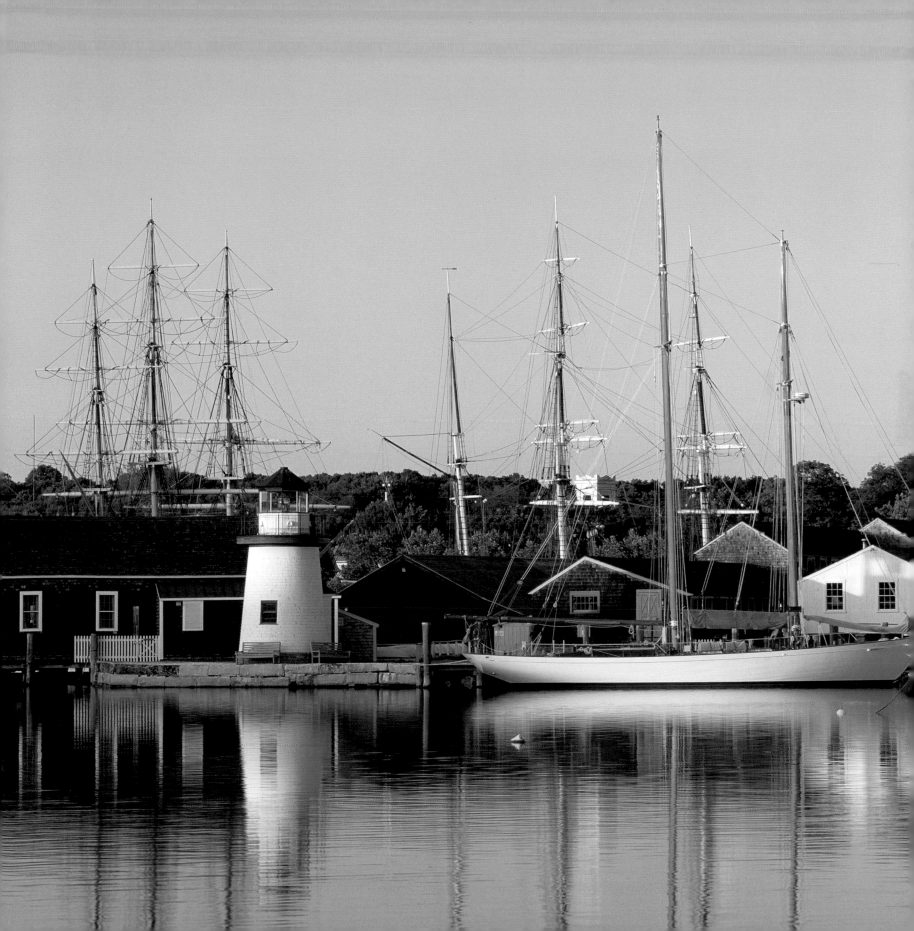

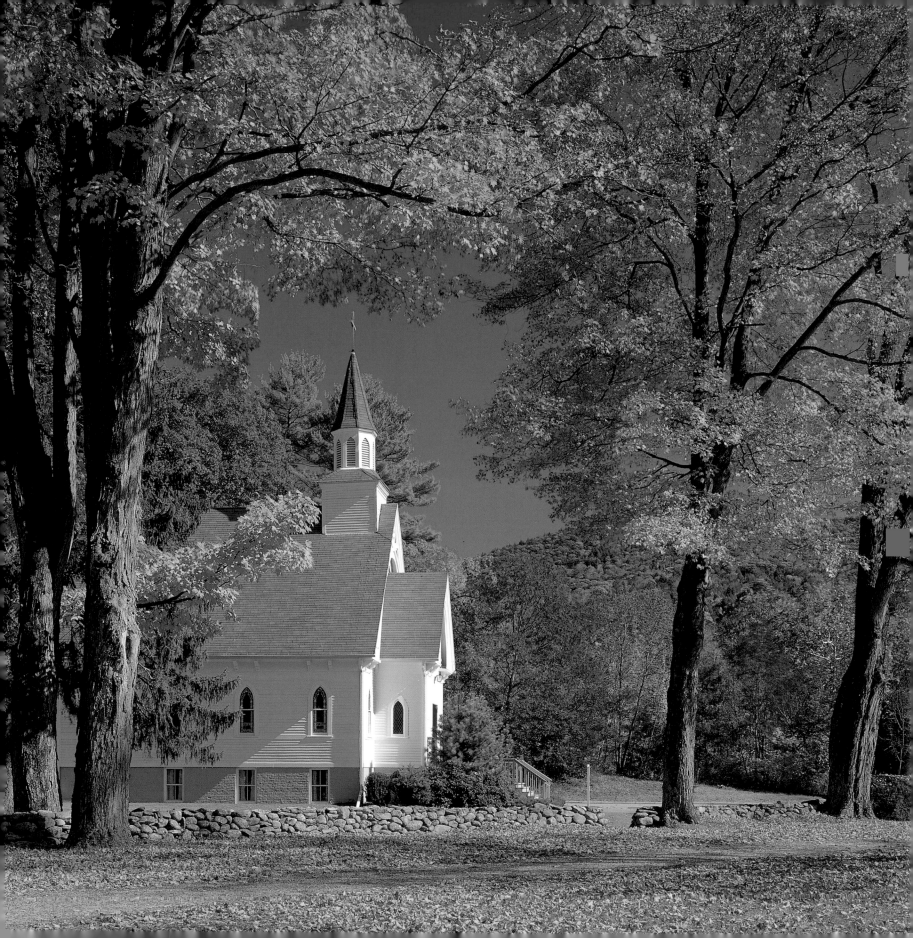

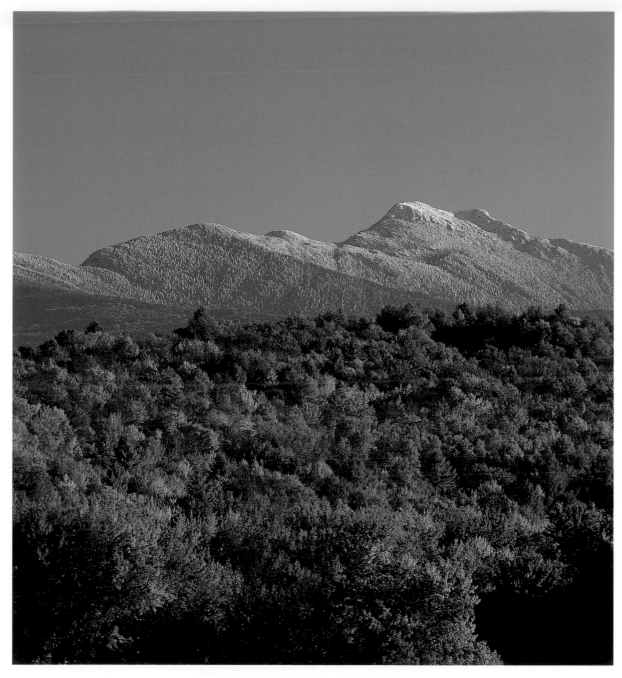

◄ Famous for its picturesque churches, stone
walls, and maple trees in fall, all of New England seems
to be depicted in a single photo taken at Cornwall Bridge, Connecticut.
▲ At 4,393 feet, Mount Mansfield is the highest spot in the state of Vermont.
►► Stone walls and a dirt road bisect a farm on Block Island, Rhode Island.

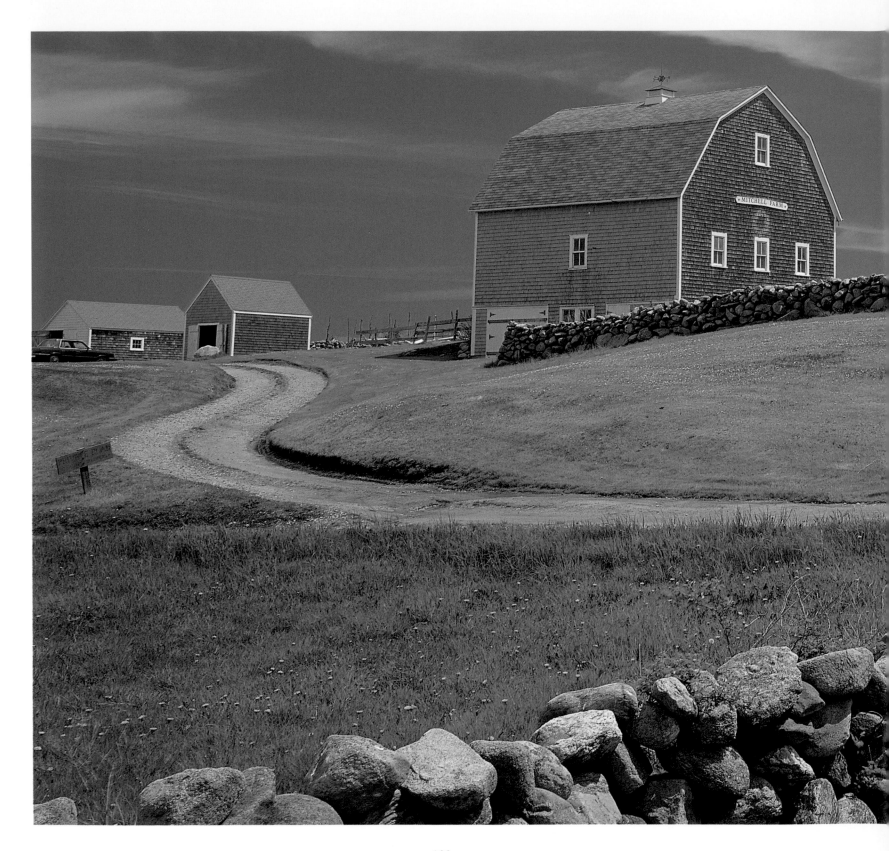

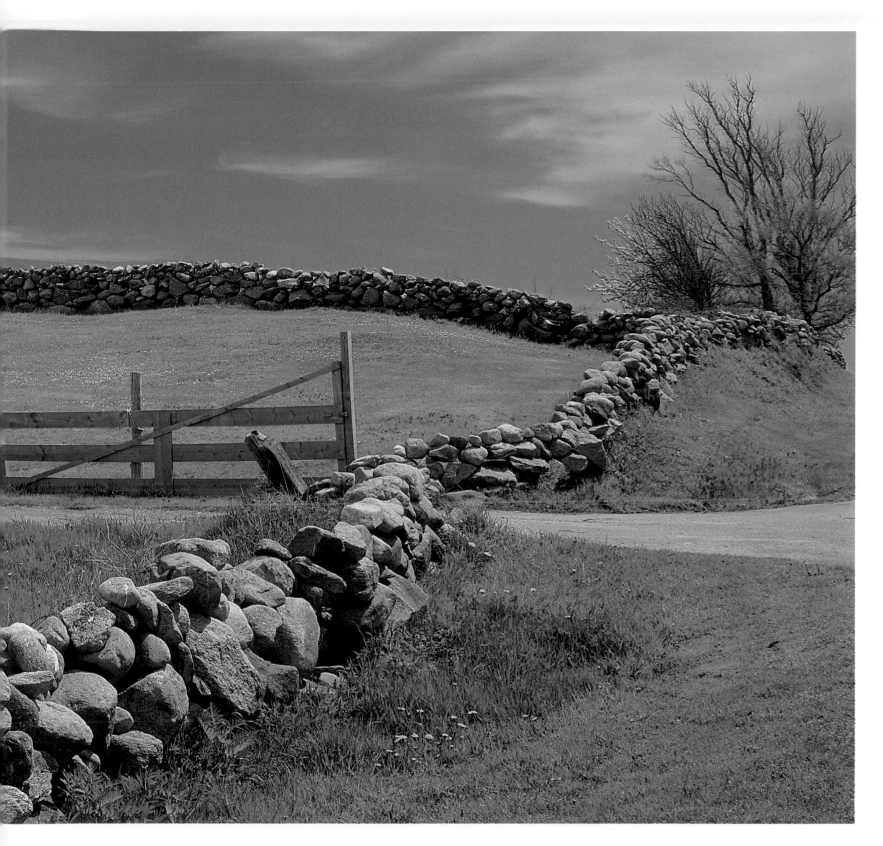

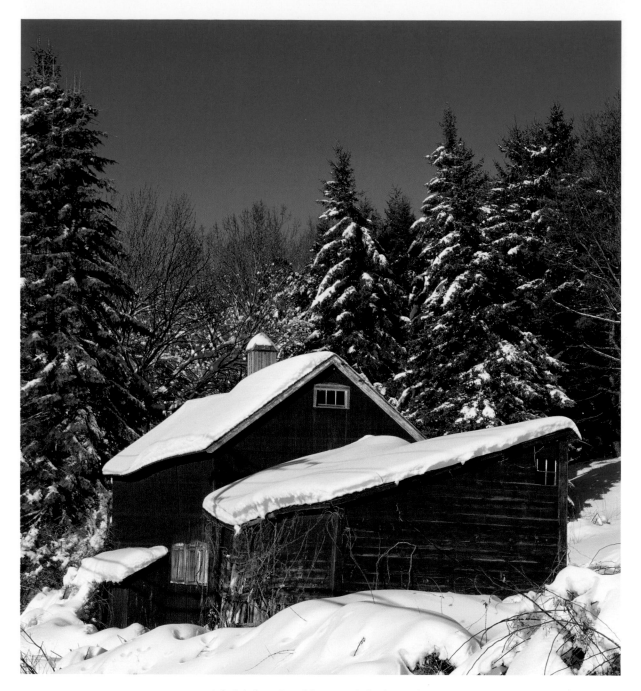

▲ A brightly painted barn and shed stand out
against a pristine snowfall near Litchfield, Connecticut.
► Ice coats each blade of grass at the 159-acre Turtletown Pond
Wildlife Management Area, near Concord, New Hampshire.
►► A swan adds to the peace and quiet at forty-eight-acre
Young's Pond Park, Branford, Connecticut. The park
includes ball fields and an off-leash dog park.

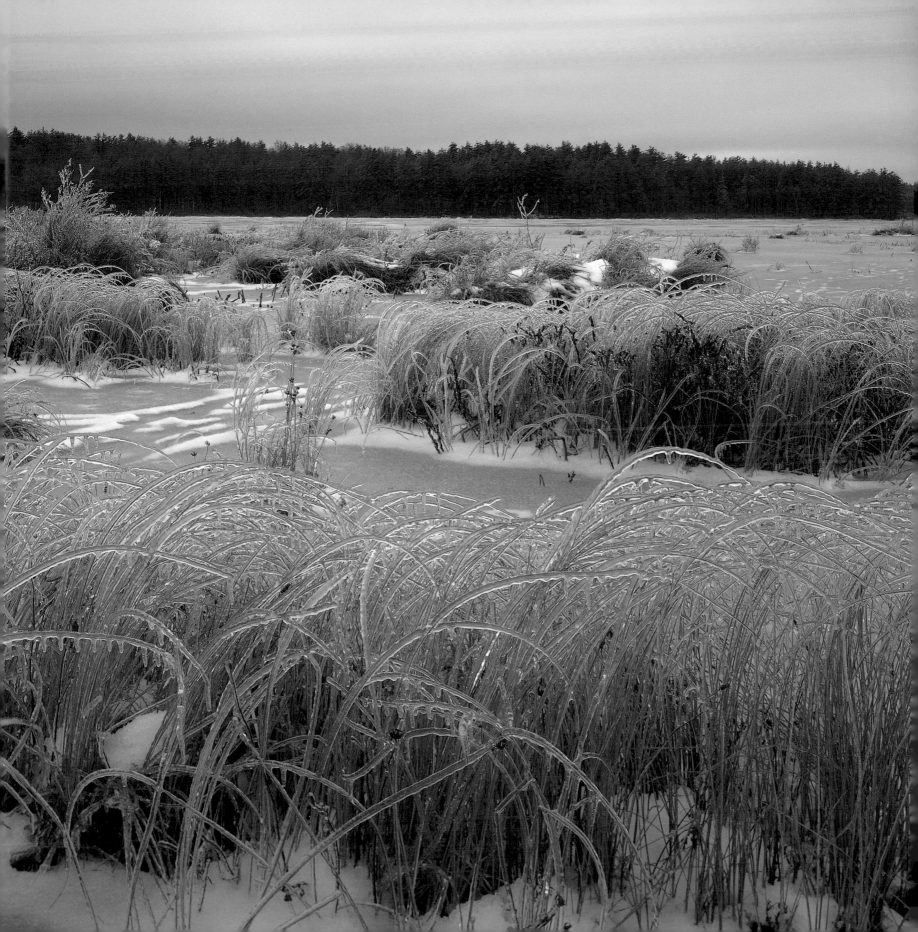

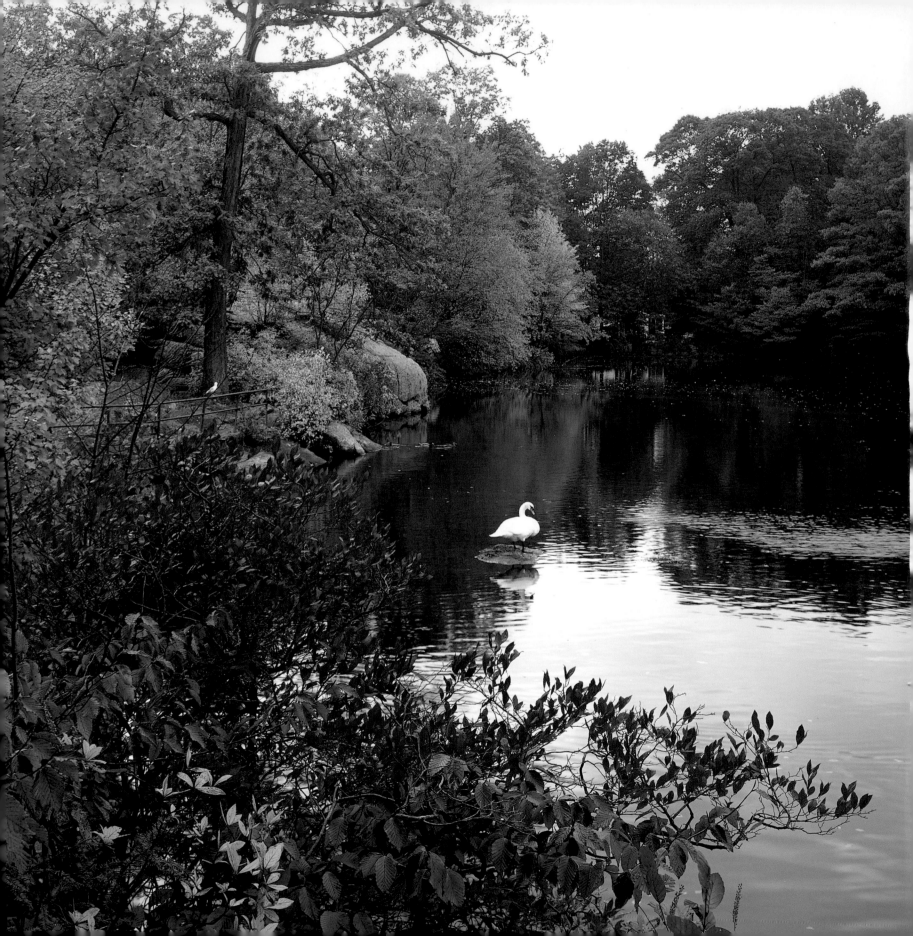